IMAGES
of America

ROSS TOWNSHIP

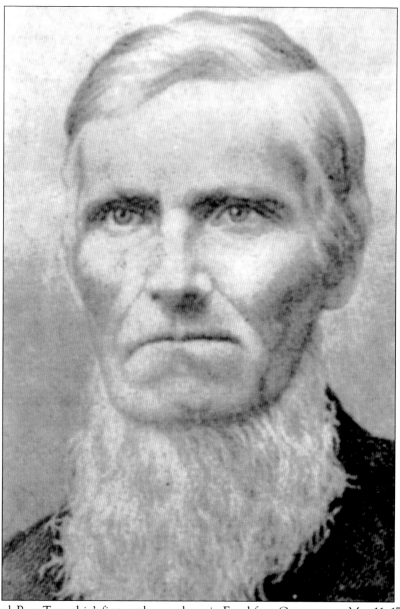

Casper Reel, Ross Township's first settler, was born in Frankfort, Germany, on May 11, 1742. After first settling in Lancaster with his family in 1761, his mother, brother, and sister were murdered by Indians. This brought Reel to Fort Pitt, where he became skilled in the trading business and also made breeches for other early residents of Pittsburgh. After fighting in the Revolutionary War, Reel returned to Fort Pitt and made his way north along the rivers and built a log cabin in what was then known as Pine Township in 1792. He was chased out by the Seneca Indians of the area and later returned with his family in 1794. His house still stands at 148 Georgetown Avenue. (Ross Township Historical Society.)

ON THE COVER: Shown in 1902, the one-room Perrysville schoolhouse was a staple of education in early Ross Township. It started in 1798 and continued until the last class graduated in mid-1922. It was located on the corner of Hiland Presbyterian Church's cemetery. (Ruth Dodds.)

IMAGES
of America

ROSS TOWNSHIP

John D. Schalcosky

ARCADIA
PUBLISHING

Published by Arcadia Publishing
Charleston, South Carolina

Printed in the United States of America

Library of Congress Control Number: 2010936762

For all general information, please contact Arcadia Publishing:
Telephone 843-853-2070
Fax 843-853-0044
E-mail sales@arcadiapublishing.com
For customer service and orders:
Toll-Free 1-888-313-2665

Visit us on the Internet at www.arcadiapublishing.com

This book is dedicated to my family and my ancestors, for whom I will always proclaim my gratitude for gifting me a passion for an insatiable quest for knowledge and creativity. I would also like to dedicate this to Ann Fischer Baumgartner, who contributed many images and sadly passed away during the writing of the book.

CONTENTS

ACKNOWLEDGMENTS

I would like to thank the Ross Township Historical Society (RHS) for not only all of the great meetings that they organized, but also for the friendships that have evolved through them. Many of the photographs came from members of this organization, as well as the wonderful collections of Sandy Brown (SB), M. Susan Campbell (MSC), and Grace Stanko. Without their help and contacts, this project would have not been complete.

Thanks to my wonderful editor at Arcadia Publishing, Erin Vosgien; this book would not have happened without your proficient guidance.

To all of my friends for showing me such amazing support and excitement, especially on Facebook; I could not have written this without you. I would also like to thank specifically Ruth Faulk Dodds (RD) for her wealth of knowledge and amazing photographs of Perrysville; John Reel (JR) for his wealth of photographs on the Reel family; Diane Machesney (DM) and her mother, Ann Fischer Baumgartner, for the photographs of their family and her many photographs of Saint Teresa of Avila church and school; Rev. Larry Ruby of Hiland Presbyterian Church (HPC) for letting me search through every cabinet in the old 1836 church building for any and all photographs that I could find; Diane Holleran for teaching me what it means to be organized and for her wealth of knowledge; David and Missy Santillo (DMS) for their photograph and great enthusiasm toward all that is historic; George Meyer (GM) for his photographs and sense of adventure in all that we do together; Heidi Hoffman of Northway Mall (HH) for finding some great photographs that brought back more memories than she will ever know; Tammy Swann (TM) and her family for the great photographs of the 1806 Fairly homestead; Kathy Pozar for her amazing book about Laurel Gardens; Abigail Riley, my companion, for always putting up with me through the good times and bad, as well as being the best friend anyone could ask for; Leon, my feline buddy, for always cheering me up; Lana Mazur, the Ross Township Board of Commissioners; Pete Geis and Vickey Trader for putting up with my random historical photographs always laying around their desks; and John Makar (JM) for his photographs of the Harmony line and amazing resource of knowledge about all that is transportation—I thank you.

Additionally, I would like to thank all of the many people who were kind enough to donate their photographs and share their stories for the creation of this book. I would also like to thank all of the families of Ross Township, both living and deceased, who with keen awareness of their surroundings, were smart enough to snap some photographs.

Finally, to my wonderful parents, Richard and Sherry Schalcosky, whose love and support I will always cherish.

INTRODUCTION

Close your eyes and imagine a land covered in wilderness, Indians hunting throughout the grounds, and log cabins beginning to be built. The year is 1809. Abraham Lincoln is born, Thomas Jefferson just ended his term as president and six miles from Pittsburgh, Ross Township is now formed. The area was named after a prominent Pittsburgh attorney, James Ross. He represented Western Pennsylvania at the convention to ratify the Pennsylvania Constitution in 1790. Ross was a U.S. senator and the personal land lawyer of George Washington.

Often, early settlers lived in fear of Native Americans since many Indians did not agree with Chief Cornplanter's 1784 treaty with George Washington. Ross Township was the Seneca tribe's hunting grounds and the "white men" were trespassers. Not until 1794 did Casper Reel decide to finally settle in the Ross Township area, after being formerly chased out by a group of Indians. His twin sons, David and Casper Jr., became the first white men born north of Pittsburgh.

One of Ross Township's earliest claims to fame was the roads that passed through the area. The Native Americans traveled the Venango Path, later called Franklin Road, which was one of the most important routes used by Commodore Oliver Perry during the Battle of Lake Erie in the War of 1812. After his victory, the road was changed to the Perrysville Plank Road. During this time, the roadway had large wooden planks on one side to assist in traveling during inclement weather. In the 1920s, state Sen. Herman P. Brandt petitioned to have the road paved from the Pittsburgh city line to Perrysville. The road changed names once again and is now known as Perry Highway.

Along the road, the Hiland Presbyterian Church was built around 1799. The church, which still stands today, served as the hub of the community with most of the early families worshiping there and using it as the town meeting hall. Adjoined to church property was the Perrysville schoolhouse. This was the setting of one of both Pittsburgh's and Ross Township's most infamous prison escapes.

On January 30, 1902, Katherine Soffel, wife of the warden of the Allegheny jail, helped Ed Biddle—with whom she was in love—and his brother, Jack, escape. It was during this escape through a blinding snowstorm that they found themselves on Perrysville Plank Road looking for shelter, transportation, and something to eat. Having nowhere else to stay, they broke into the one-room Perrysville schoolhouse and warmed up next to the pot-bellied stove that was still warm from the day's classes. Wanting something to eat, the Biddles traveled up the road to the White House Hotel were they requested six ham sandwiches and a pint of whiskey. Realizing they were short on cash, Ed Biddle pulled out a woman's pocketbook and paid for them. He did not have enough room in his coat so he pulled out his gun in full sight of the bartender, Christ Weller. After many failed attempts to steal horses and a buggy, they found an open barn along Three Degree Road where their attempt proved successful. Word of their escape broke out in the morning on January 31; they were tracked and later caught in Butler County.

Along with these infamous strangers, others residents of Ross Township have had famed lives as well. Herman P. Brandt was a state senator, Casper Reel and Jacob Weitzel were notable Revolutionary War soldiers, and Simon Girty was a renegade traitor to the settlers and has been written about many times all over the world. These are just a few of the many wonderful stories that make the township a magnificent place to live. Ross Township is a community that is building a new history for generations to come.

One

GENERATIONS OF THE PAST

Simon Girty (1741–1818) was
just a young boy when his family
was captured by Seneca Indians
who later adopted his family as
one of their own. During the
breakout of the Revolutionary
War, Girty served as an Indian
interpreter between the British
and their Native American
allies. Because of this and
various other reasons, the early
soldiers and generals at Fort
Pitt considered him a "turn
coat" and renegade traitor of
the Americans. Girty's Run,
the creek that runs parallel
to Babcock Boulevard, was
named after him due to the
legend that Simon was chased
down at its very banks by
early Ross settlers. (RHS.)

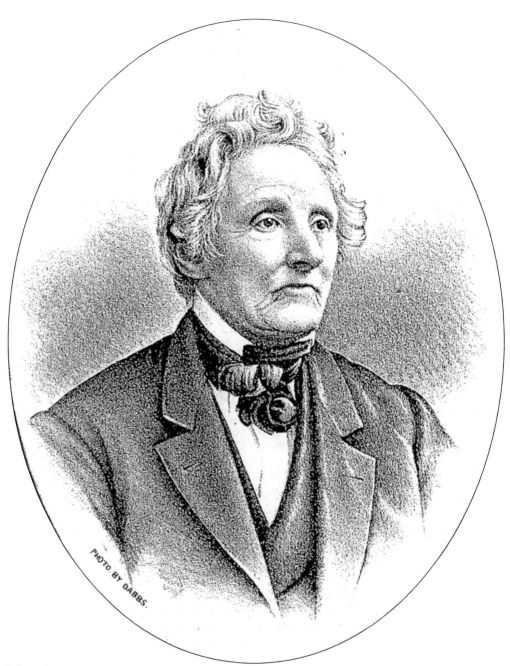

John Thompson was born in County Down in Northern Ireland in 1767. He immigrated to America and later met his wife, Eleanor David, on a large farm that he bought on McIntyre Road. Together they had 16 children, 14 of whom survived into maturity. Thompson tried to enlist during the War of 1812, but was turned away due to his old age. He continued living on his farm until his death in 1851 at the age of 84. Thompson Run Road was named after him and his family. (RHS.)

Posing in this photograph is Jacob Good Reel and his wife, Annie Donnell. Reel was born in June 1827 in the old log cabin of his grandfather, Casper Reel. He took up the trade of gardener in his youth and later became a notary public in Perrysville by the turn of the century. During his life he kept an old family Bible that had saved his grandfather from a stray bullet during his service in the Revolutionary War. (JR.)

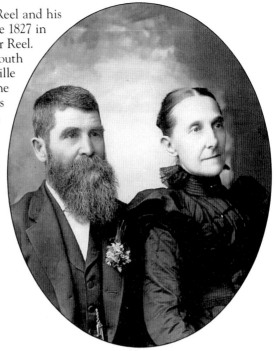

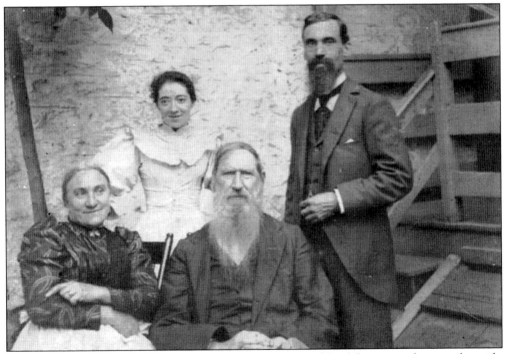

In this only known photograph of Casper Reel's son, Conrad Reel, he is seated next to his wife, Rosanna Good (1806–1886). Their daughter, Annie Eliza Reel (1834–1911) and son-in-law, Hugh Edward McGuire, stand behind them. Born on June 22, 1795, Conrad and his twin brother were the first white children born north of Pittsburgh. Later in his life, Conrad became the first postmaster in Ross Township. He died in 1870. (SBC.)

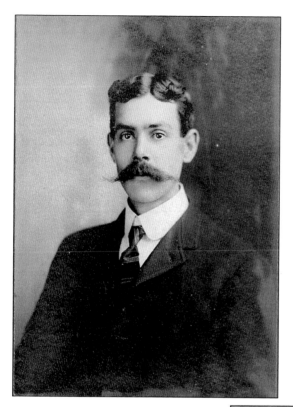

John Jackman Reel was born on his grandfather David Reel's homestead on February 26, 1876. He was best known and remembered as a collector and enthusiast of all types of items, most of which he put into his famed "hobby room" at the old residence. His collection included World War I grenades and early beaver traps used by his great-grandfather Casper Reel on his many journeys up the Ohio River. (JR.)

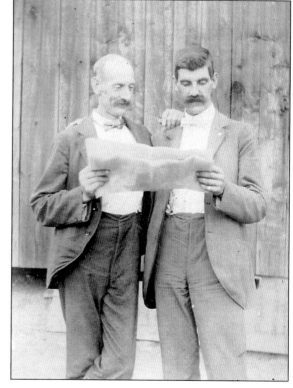

William Volentine Reel, born in 1831, stands next to his son John Jackman Reel at their house on Courtney Mill Road. William was named after Casper Reel's brother-in-law, William Volentine. As Volentine was crossing the Niagara River above the falls with another man, the current of the river became so strong that Volentine lost control of his canoe and started heading toward the falls. The other man leaped out and swam to safety, but Volentine was not as lucky—he disappeared over Niagara Falls, never to be heard from again. (JR.)

Andrew Jackman, born in 1810, was a descendant of one of the oldest and most highly respected families in Allegheny County. He was the earliest settler in the valley below Jack's Run Road, which was later called "Bellevue" by others for its "beautiful view." Bellevue was once part of Ross Township, along with all of Allegheny City, North Side, Reserve Township, Millvale, and McCandless. Jackman was also a very well-respected farmer during his lifetime. (JR.)

William Jackman III was born on February 21, 1824, in Ross Township. After the death of his father, he took over as manager of his family's farm. In 1878 he opened a grocery store that he conducted successfully for 12 years. Jackman married Elizabeth Reel in 1856, and they had five children. (JR.)

Elizabeth Jackman Reel was born in 1847 on her father's farm near the borders of current Ross Township and Bellevue Borough. By the time this photograph was taken, around 1865, she was married to William Volentine Reel. She lived a full life, dying at the age of 85 on November 3, 1916. (JR.)

Rupert Fischer, right, poses for his very first photograph on American soil sometime around 1890. Seated to the left is his brother Joseph, who died on March 23, 1890, at the age of 16. (DM.)

14

On January 25, 1898, Catherine Brunner married 26-year-old Rupert Fischer in the old Saint Teresa of Avila church. Rupert, who was born in Eppingen, Baden, Germany, was sent to live with his aunt after his mother, Albina Veith, died during the birth of her sixth child. Rupert was not happy with that decision and at 16 years old left for America with two of his teenage friends and his brother. (DM.)

Wiley Graham Reel is pictured with his family around the early 1860s. He enlisted during the Civil War with his brother George in 1862. He was in Company E of the 101st Pennsylvania Infantry Regiment and participated in many battles. He was promoted to sergeant and was later captured and held prisoner in the infamous Andersonville prison, where his brother had died. After surviving the inhumane treatment of the prison, Reel accidentally drowned near Fort Monroe on his way home. (JR.)

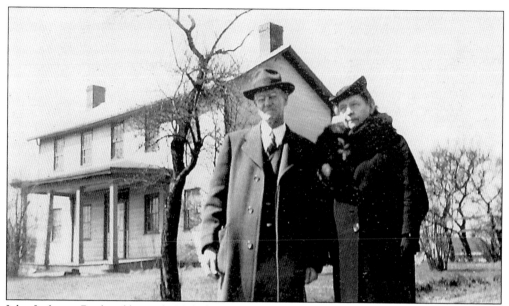

John Jackman Reel and his wife, Mabel Porter (1884–1969) pose for a photograph in front of the old Reel homestead on Courtney Mill Road. (JR.)

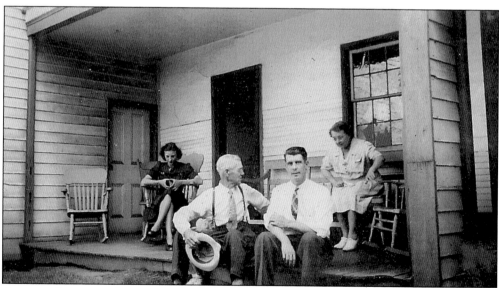

A scene of many good times, the back porch of the old David Reel homestead is seen in this photograph. Pictured are, from left to right, Dorothy Geis Reel (1925–2008), John Jackman Reel (1846–1965), his son Homer Renton Reel (1923–1978), and Mabel Porter (1884–1969). (JR.)

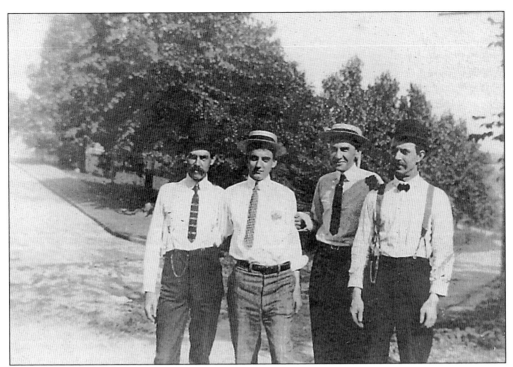

John Jackman Reel, pictured on the far left, stands with three unidentified young men at the entrance to his family's farm on Courtney Mill Road. (JR.)

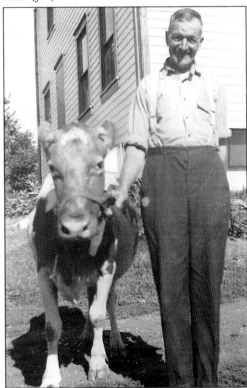

Rupert Fischer is pictured in front of his home on Good Lane with his prized cow. After leaving his farm on McKnight Road, Fischer moved his family of nine children to Perrysville. (DM.)

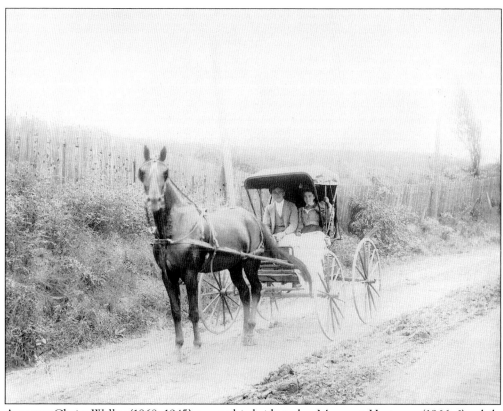

A young Christ Weller (1868–1945) courts his bride-to-be, Margaret Hartman (1866–?), while going for a ride in a horse-drawn carriage in early Perrysville sometime around 1892. (MSC.)

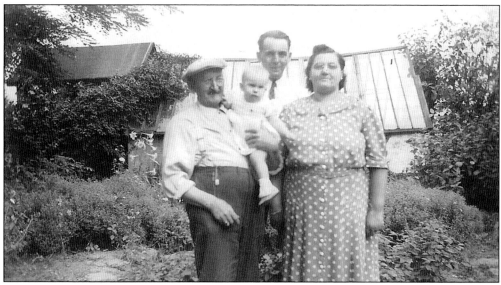

Taken in 1943, Christ Weller proudly holds his granddaughter M. Susan Campbell in the company of his son-in-law James Barnett Campbell (1885–?) and daughter Margaret (1894–?). Weller was the bartender at the White House Hotel in 1902 when the Biddle brothers broke out of prison and stopped at the hotel as they fled Perrysville. (MSC.)

Estella Beuerman was born in Ross Township on March 13, 1889, to Adolph and Sarah Heiber Beuerman. After the death of both of her parents when she was only 10 years old, Estella moved in with her grandparents, the Heibers, whose son Charles ran the Heiber general store next to Brandt's funeral home from 1898 to 1959. (RD.)

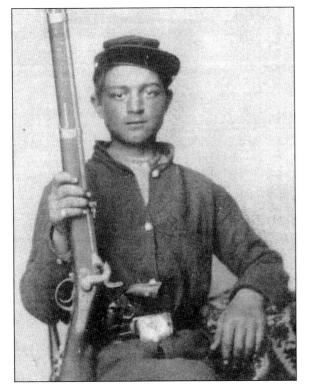

George Deimling, like many soldiers in the Civil War, lied about his age so he could join and fight against the South. He was barely 17 when this photograph was taken in 1862. He rose to corporal and was taken prisoner at the Battle of Gettysburg. He escaped and returned to Perrysville by 1864. Deimling married Verena Wilt and had three daughters. Fanny and Marina died in infancy and Della May, the youngest, survived to marry Charles Heiber. (RHS.)

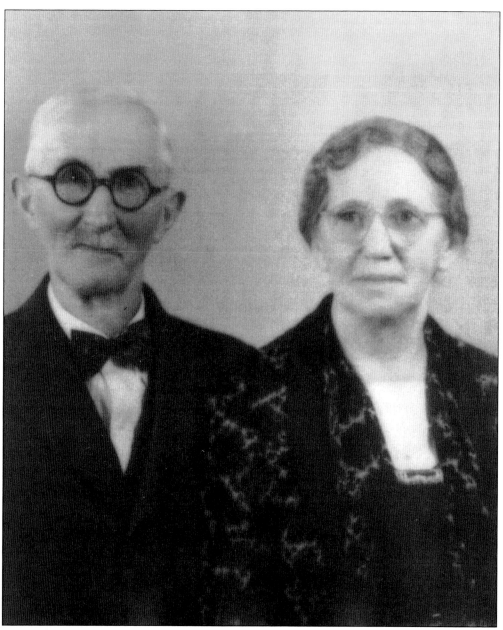

Harry Alexander English (1864–1942) and his wife, Amanda Caroline Groetzinger (1869–1961), are pictured here. They owned a large farm in Ross that was located at 7160 Rochester Road. The English family owned the farm from around 1840 until its public sale in 1949. The original homestead and barn still stand today. (SB.)

Josef Franz Rebel (1870–1961) sits for a photograph with his new bride, Mathilda Weidenweber (1878–1941), in 1897. Rebel met his wife when he was hired to help the Weidenweber family move from their old farm on McIntyre Road. (MSC.)

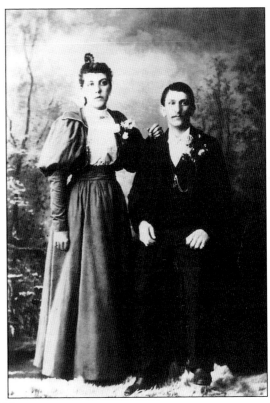

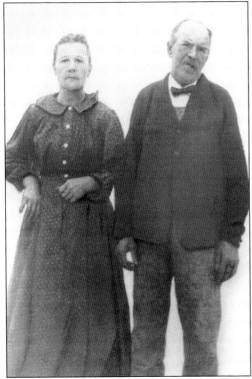

Born in 1850, John Weidenweber married Henrietta Ginser (1857–1933) and started a large family on his chicken farm along McIntyre Road during the late 1880s. (MSC.)

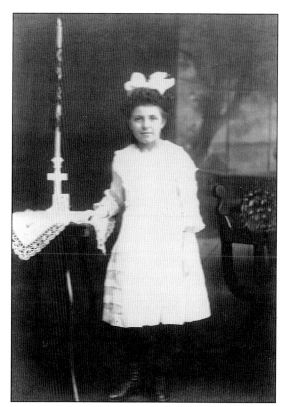

The photograph at left features a young Ann Fischer on the day of her First Holy Communion at Saint Teresa of Avila church in Perrysville around 1921. She came from a large family of nine siblings. She was born on June 18, 1913, on her parent's farm on McKnight Road. Pictured below is Ann as a teenager on her father's farm. She later married Ralph Baumgartner in 1946 and started a family of her own. She passed away at the age of 97 on October 3, 2010, just a week before giving the author these photographs of her family and the old Fischer farm. (Both, DM.)

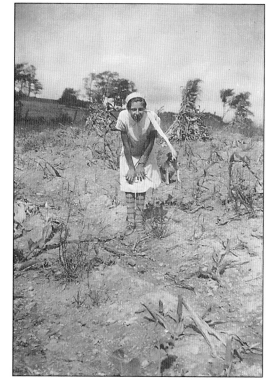

Christ Weller Jr. and Margaret Weller pose for an Allegheny City photographer in 1895. Christ Sr. was the bartender at the White House Hotel at this time. (MSC.)

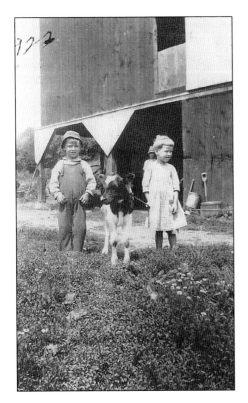

Raymond Rebel (1914–2000) and his sister Mathilda (1916–1996) pose for a photograph in 1922 with a pet calf on their family farm, which was on McKnight Road near what would later be the location of Sam's Club. (MSC.)

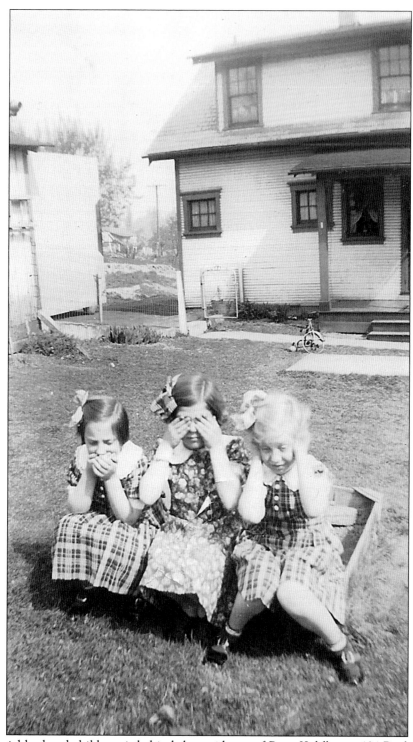

Three neighborhood children sit behind the residence of Peter Kuhlber at 104 Reel Avenue. The "see no evil, hear no evil, speak no evil" girls are, from left to right, Erma O'Boyle, Dorothy Kuhlber, and Eileen O'Boyle. (MSC.)

This portrait, discovered by the author in the Evergreen Hotel buried under piles of trash, features a young Selina Stitzer, who was born in October 1861. She was married to August Stitzer, who became the proprietor of the Evergreen Hotel sometime around 1880. Their only daughter, Adelaide, married Harry Nauman, whose family continued to run the hotel on and off until its eventual closure in 2006. (HPC.)

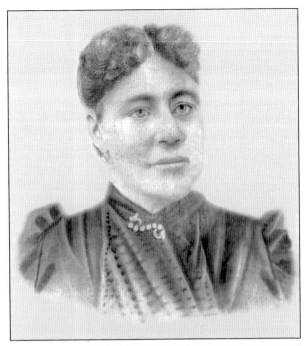

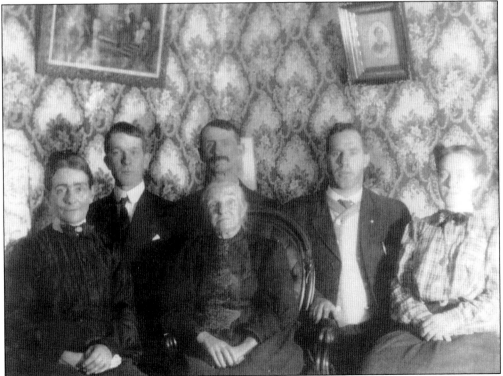

A large family gathers inside the old Sangree residence. Pictured are, from left to right, (first row) Florence Weitzel Sangree (1854–1914), Jane Weitzel (1833–1919), and Sallie Pierce; (second row) Charles Swope (1882–1949), John Roseberg Sangree (1853–1922), and Gardner Pierce (1898–1972). (HPC.)

Jane Robinson was born in Ireland and later moved to Perrysville, where she married Wilson Weitzel (1828–1903), who inherited his family's house and farm after the death of his father, Jacob Weitzel Jr., in 1875. The house, which still stands today, was built in 1814 and is located on Evergreen Road. (HPC.)

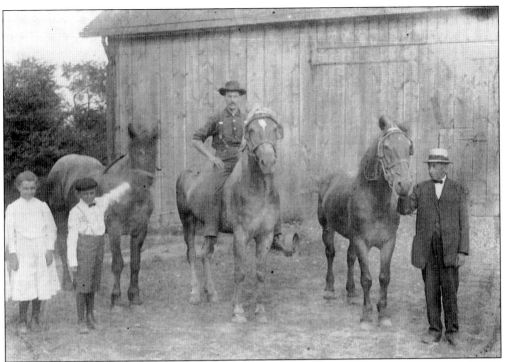

Rupert Fischer sits upon his prize-winning horse in front of his barn with his children Theresa (1898–?) and F. Joseph (1900–?), and a family friend, Milfred, to the right. (DM.)

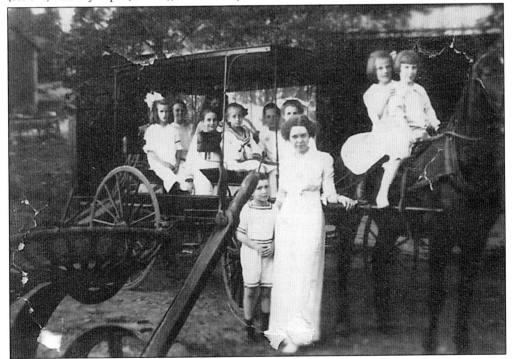

These unidentified children ride in a horse-and-buggy on their way to a school field trip in the early 1890s. (RD.)

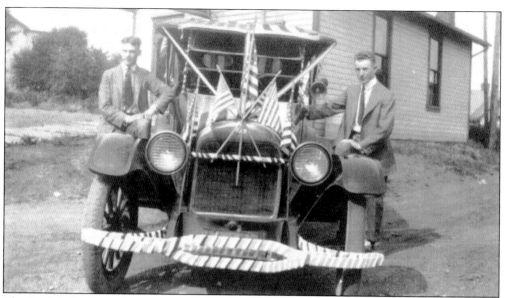

The English family readies its truck for the annual Perrysville parade. (RHS.)

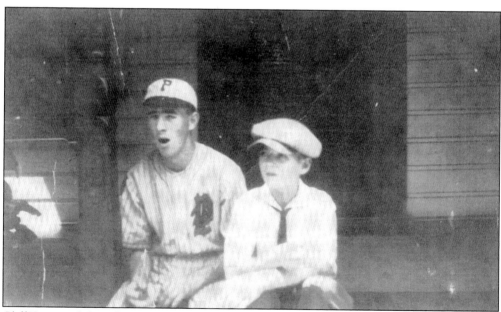

Cliff Kummer, left, and Paul Brandt are shown after enjoying a day of Perrysville baseball. Kummer later went on to own a successful meat market along Perry Highway. (RD.)

A young Joseph Fischer helps his father, Rupert, shuck corn on their family farm on McKnight Road around 1907. (DM.)

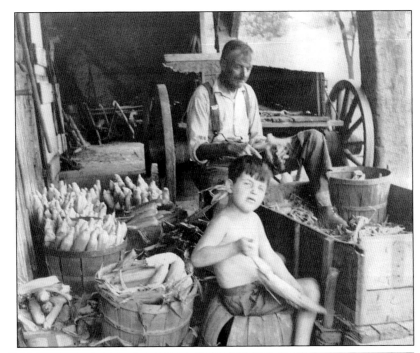

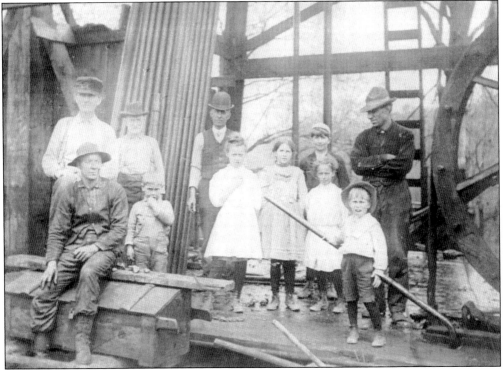

This early photograph shows the Brooks family hard at work on an oil pump that was located on Thompson Run Road. At one time there were as many as 30 oil wells around Ross Township, including ones on McKnight Road (near the current AAA) and along the fields behind McIntyre Shopping Center. (TM.)

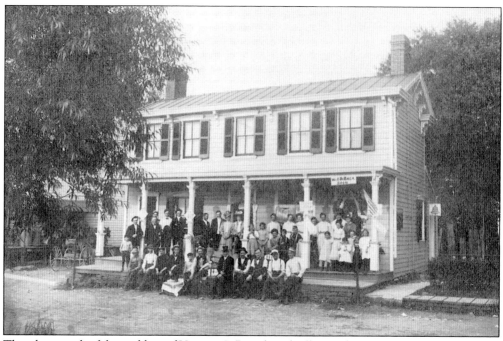

This photograph of the wedding of Herman P. Brandt and Allie Heid was taken in front of Brandt's funeral home in 1907. Brandt was a Pennsylvania state senator in 1928 and was responsible for having Perry Highway paved from the Pittsburgh city line to Perrysville in 1929. (RD.)

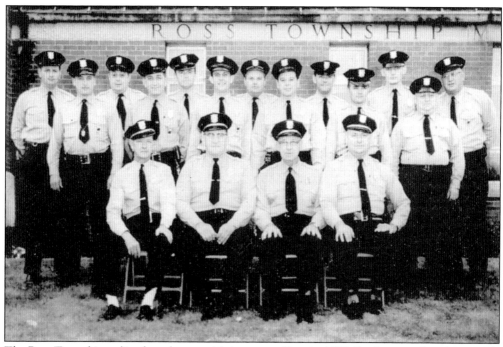

The Ross Township police force began with just one officer in 1922. By the time this photograph was taken in 1961, Ross Township had acquired two motorcycles and four cars. Edward Schohn, Ross Township's first police chief, is pictured in the front row, third from left. (RHS.)

Two

PERRYSVILLE

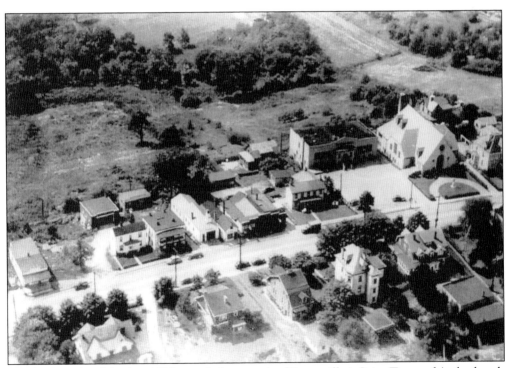

On the far right of this late 1930s aerial photograph of Perrysville is Saint Teresa of Avila church and the old rectory that is now "the Great Hall." Directly across the street is Good Lane; the barely visible house at the bottom right corner was the site of the infamous Dempsey murders that occurred on Christmas Eve 1934, when Katheran Schoch of New York killed her brother and his four children after a nice Christmas dinner. Behind Saint Teresa of Avila was Turner's Grove, the site of many family and school picnics. It is now occupied by Lindley Lane and the new Saint Teresa of Avila church, which was built in 1983. Toward the middle of the photograph is Perrysville Volunteer Fire Company, which was founded in 1908 and is still in operation today. (DM.)

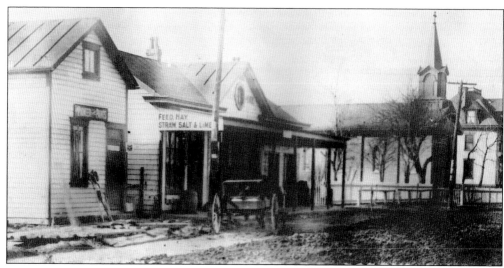

This earliest known photograph of Perrysville, taken sometime in the late 1860s, serves as a great example of the early roads of Perrysville. The roads could become very muddy after a heavy rainstorm. On the left is Austin T. English's general store. A little farther down the road is the original Saint Teresa of Avila that was built on July 4, 1866. (RD.)

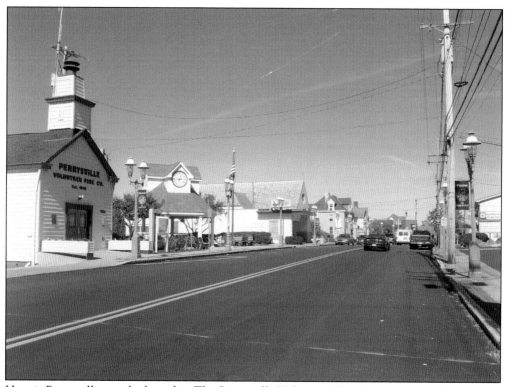

Here is Perrysville as it looks today. The Perrysville Volunteer Fire Company is on the far left. At one time, the firefighters responded to calls as far away as Warrendale. A gazebo was placed near the site of the old English general store by the Perrysville Business Association in an effort led by Grace Stanko. (Author's collection.)

This photograph, taken the day after the Biddle brothers escaped through Perrysville in 1902, shows the sleigh tracks down Perry Highway. The house on the right belonged to the family of J.B. Heid and is still standing today at 932 Perry Highway. (RD.)

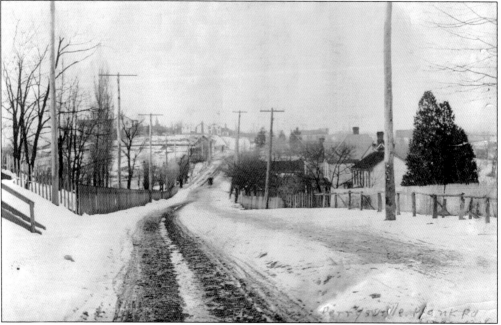

Taken during the winter of 1908, this photograph shows the Saint John's Lutheran church cemetery on the right looking all the way up Perrysville Plank Road towards Saint Teresa of Avila church. At this time the road was planked on the right side only for easier travel during the more inclement weather. (RD.)

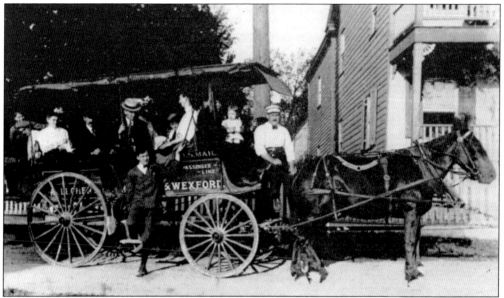

This early photograph, taken at an unknown location along Perry Highway, features the Allegheny, Perrysville, and Wexford stagecoach with two mules that brought mail every day from East Street up to Wexford. Sometimes it took up to two days for mail to reach recipients only seven miles from Pittsburgh. (JM.)

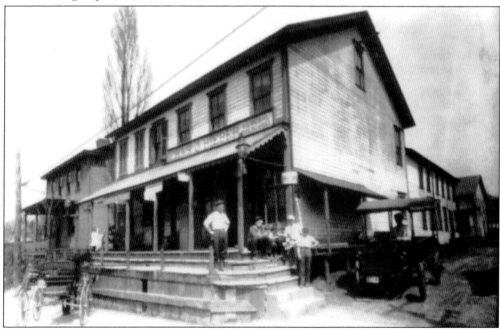

This is the Heiber general store, which was located on the corner of Perry Highway and Jackson Street. Charles Heiber and William H. Brandt opened the store in 1898. After splitting ways with each other, Heiber took on the task of running the store by himself. On November 26, 1902, he married the daughter of George Deimling, Della. Together they had five children. Charles Jr. ran the store until 1959. It sold everything from feed and hay to shoes, clothing, hardware, groceries, and penny candy. (RD.)

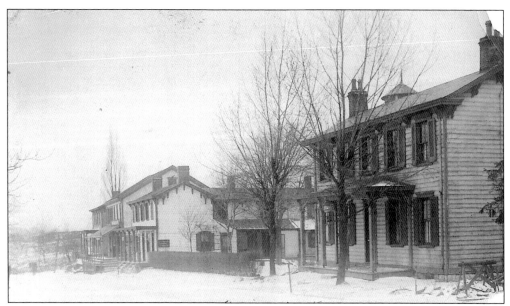

Taken in front of the Heiber house in 1908, this photograph best represents where Perry Highway stopped and continued behind the current Dairy Queen today. Down the road is Brandt's funeral home and the general store. Heiber's general store had the first phone in Ross Township. (RD.)

This is the Heiber house that was owned by Charles Heiber, born in 1863 in Beaver County. He left his family's farm at the age of 22 and moved to Perrysville, where he originally started a blacksmith shop. (RD.)

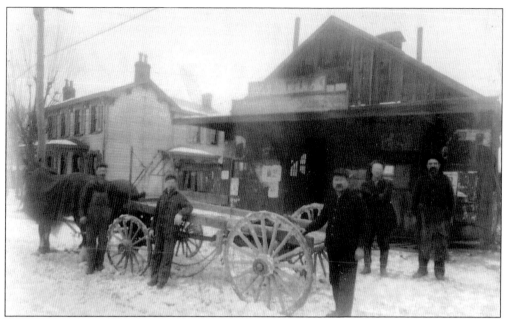

This photograph of the Heiber blacksmith shop was taken in 1912. It was located at 1024 Perry Highway. Charles Heiber is pictured to the right on the cart that he used to transport goods. (RD.)

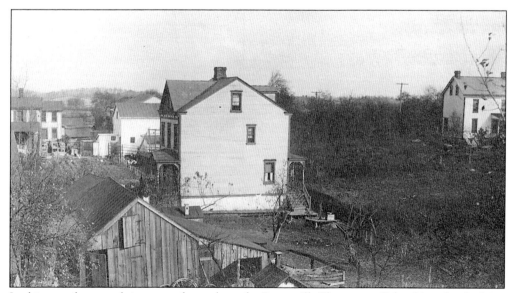

In this rare photograph is a scene from where the Perrysville Elementary School is today, looking down the valley toward Shars Lane. This photograph was taken in 1915. (RD.)

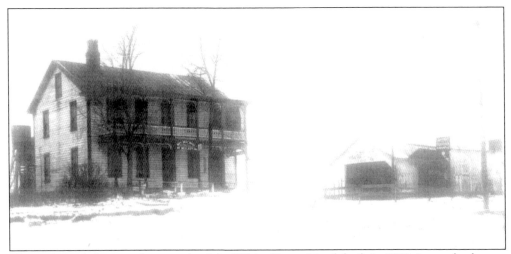

This is the only known photograph of the White House Hotel, built in 1849. It was the famous hotel where the Biddle brothers stopped during their jailbreak in 1902. The building still survives and is now an apartment complex that is painted blue. (RHS.)

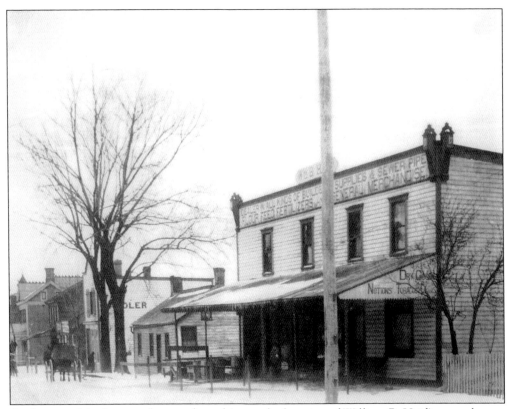

At the time this photograph was taken, this was the location of William B. Heid's general store. It was later occupied by Henry Zehner's funeral home. It is the present location of Perrysville's oldest existing bar, the Perrytowne Tavern. Notice the hitching posts outside for horses. (SB.)

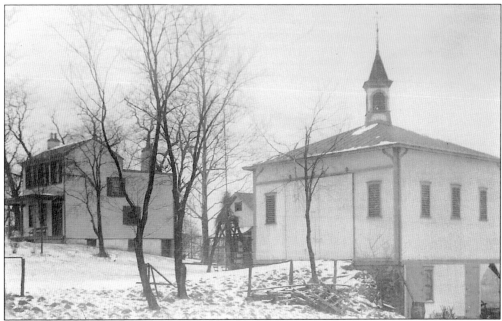

This is the house that George Deimling and his wife, Verena, occupied for many years. It is still standing and has occupants today at the corner of Deimling Road and Perry Highway. (RD.)

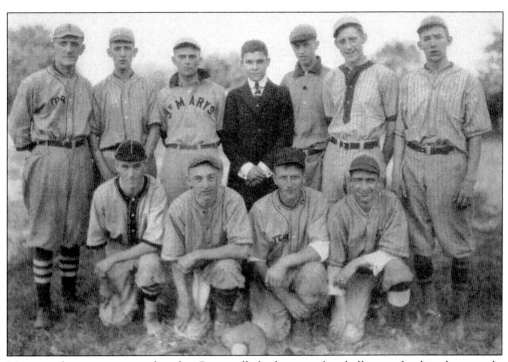

Most people may not remember that Perrysville had its own baseball team. In this photograph, taken sometime around 1918, the only man that can be identified is Cliff Kummer, who is kneeling on the far left. (SB.)

This is probably the most recognized intersection in Perrysville, Rebel's Corner. Joseph Rebel and his wife, Mathilda, moved to the house on the right in 1922. They soon operated an extremely popular barbecue stand and store on the corner of Sewickley Oakmont Road and Perrysville Avenue. The building is now owned by Willi's Ski Shop. (MSC.)

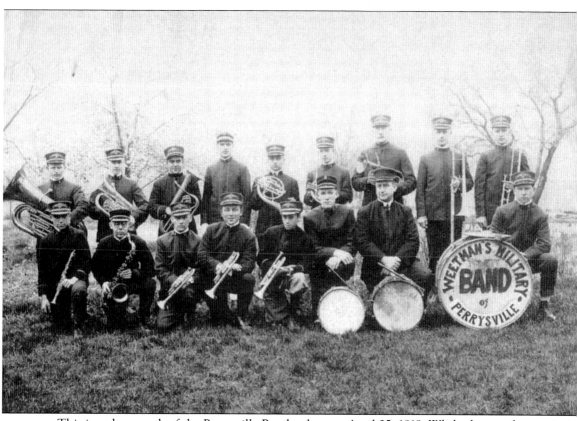

This is a photograph of the Perrysville Band, taken on April 25, 1918. While the members are not identified in the photograph, a list of the band members was given in a program from that concert. Included are president William Wally, secretary and treasurer Cliff Kummer, director James Weetman, Ralph Winner, Dat Cassidy, Willard Uhlenburg, Herman Rall, Lute Trust, John Sundaie, Alvin Berberich, William Trust, Frank Sundaie, Walter Stierheim, Henry McQuaide, Emery Shaffer, Fred Fisher, David Persol, Joseph Sundaie, Cyrel Enders, George Novak, William Koenig, William Gray, Oliver Grotefend, and Albert Faulk. (RHS.)

Three

EARLY EDUCATION AND PLACES OF LEARNING

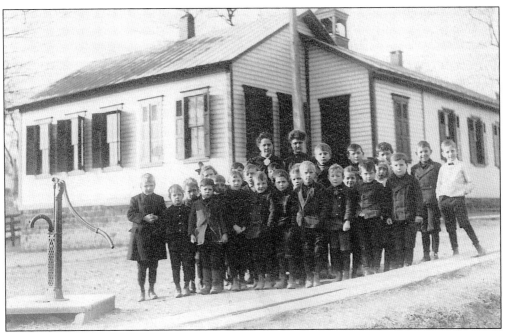

Shown here in 1902, the one-room Perrysville schoolhouse was a staple of early education in Ross Township. It started in 1798 and continued until the last class graduated in mid-1922. It was located on the corner of Hiland Presbyterian Church's cemetery. (RD.)

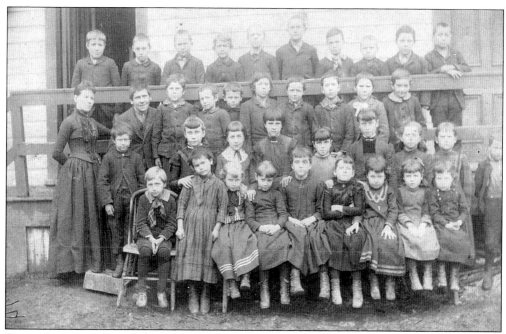

This is the earliest photograph of any school in Ross Township. The Evergreen one-room schoolhouse was located on the corner of Nelson Run Road and People's Plank Road in 1898. In those early days of education, every grade was in one room at the same time. Students shared a slate to write on, and often there was not enough room for any desks. (GM.)

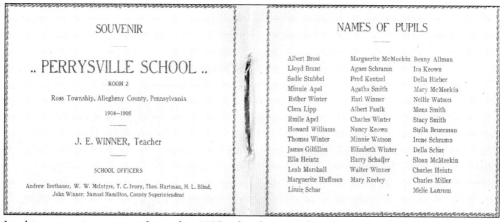

SOUVENIR

.. PERRYSVILLE SCHOOL ..

ROOM 2

Ross Township, Allegheny County, Pennsylvania

1904–1905

J. E. WINNER, Teacher

SCHOOL OFFICERS

Andrew Brethauer, W. W. McIntyre, T. C. Ivory, Thos. Hartman, H. L. Blind, John Winner; Samuel Hamilton, County Superintendent

NAMES OF PUPILS

Albert Brosi	Marguerite McMeekin	Benny Allman
Lloyd Brant	Agnes Schramn	Ira Keown
Sadie Stubbel	Fred Kentzel	Della Hieber
Minnie Apel	Agatha Smith	Mary McMeekin
Esther Winter	Earl Winner	Nellie Watson
Clara Lipp	Albert Faulk	Mena Smith
Emile Apel	Charles Winter	Stacy Smith
Howard Williams	Nancy Keown	Stella Beuerman
Thomas Winter	Minnie Watson	Irene Schramn
James Gilfillan	Elizabeth Winter	Della Schar
Ella Heintz	Harry Schaffer	Sloan McMeekin
Leah Marshall	Walter Winner	Charles Heintz
Marguerite Huffman	Mary Keeley	Charles Miller
Lizzie Schar		Melie Lanrum

In this souvenir program from the 1905 school year, John Winner is listed as the teacher of the Perrysville school. At the bottom of the program, Samuel Hamilton is listed as the county superintendent. He later had a high school named in his honor at the top of Cemetery Lane. (HPC.)

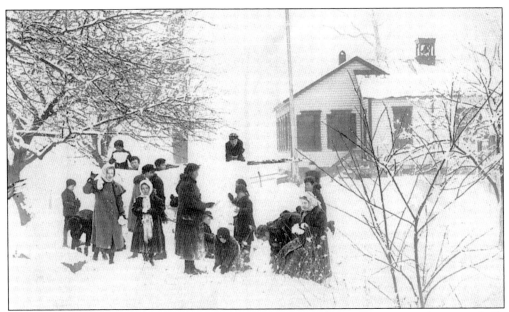

In this great winter scene outside of the Perrysville school, students play games and toss snowballs at the camera. During the winter months, teachers were responsible for lighting the fire in the pot-bellied stove that kept the school warm. Older children were let out early to split wood. (RHS.)

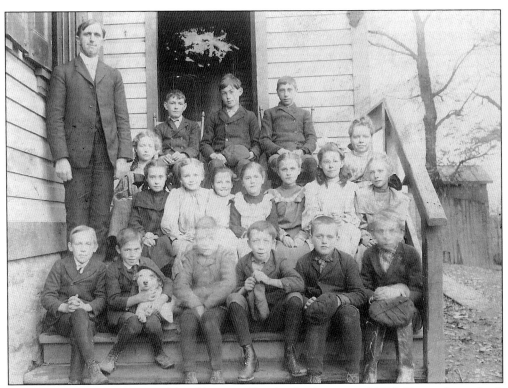

This is another scene in front of the old Perrysville school, taken around 1908. Notice the student's dog that they adopted as their school mascot. (RD.)

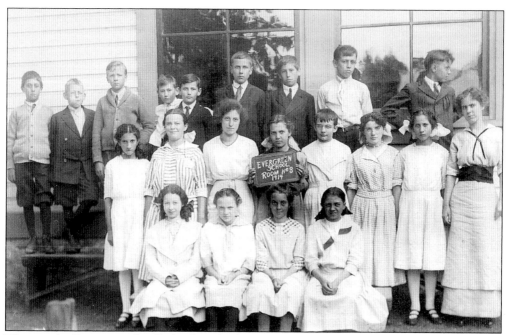

This was the Evergreen school's third-grade class in 1914. By the time this photograph was taken, children only had to be 13 years old to graduate. It was later changed to 17. Before then, children would usually have to leave school to go and work on their family's farm. (GM.)

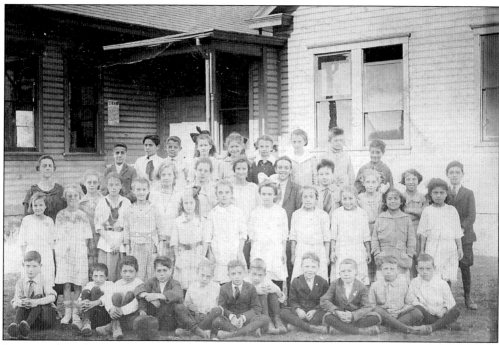

By 1918, when this photograph was taken of the first Seville school, legislation was passed that consolidated many of the one-room schoolhouses into multi-roomed facilities with separate rooms for various grade levels. Building new or modified one-room schools was prohibited. (GM.)

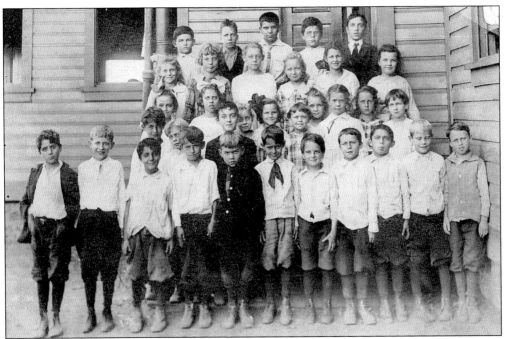

By the time of this 1920 photograph of the Seville school, students were able to ride in a bus to school. Before then, all children would either walk or ride a horse. Schools were never closed due to bad weather, so children had to hike through mounds of snow—a feat that is no longer imposed today. GM.)

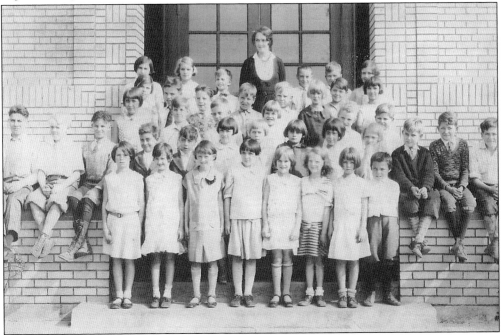

This photograph, taken on October 24, 1930, shows a large group of children in what was then the brand new Perrysville school. After attending grade school there, children had the option to go to either Perry, Oliver, or Bellevue High Schools at the township's cost. (SB.)

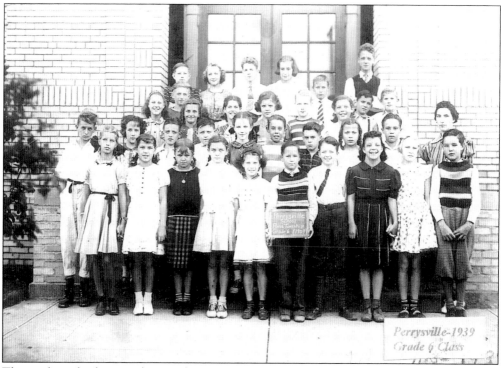

This sixth grade photograph was taken in 1939 at Perrysville school. At that time, children had the option to attend West View High School. By then, most children stayed in school through 12th grade. (GM.)

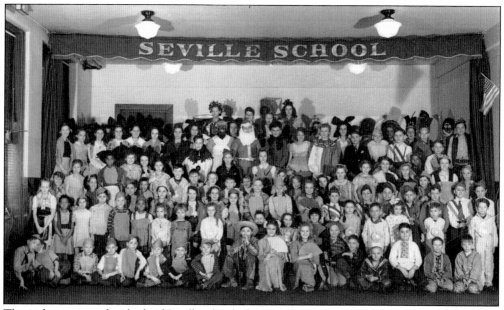

This is the entire student body of Seville school, photographed in June 1944. Just a few years later, the Ross Township School District merged with West View to form the North Hills School District. By the time these children graduated from Seville, they had the option of becoming the first graduates of North Hills High School, which began enrolling students on September 8, 1958. (GM.)

Four

SUNDAY'S BEST

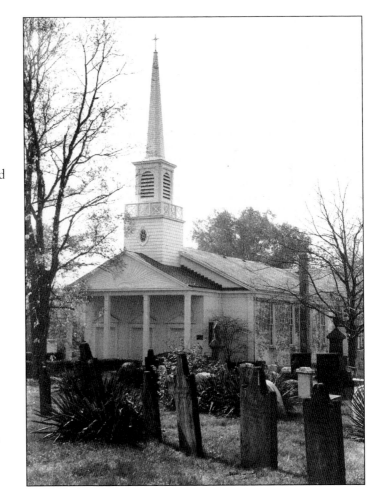

This is the historic Hiland Presbyterian Church, which sits on a site that was originally a meeting ground for early settlers. Casper Reel picked the very spot where it stands today. The church grew up around another early family, the Hilands. In 1795, Barnabas Hilands came to Perrysville and bought the land where the church is today. After moving his family, he later died after being exposed to the elements one winter. His widow, Martha, and his children inherited the land and soon plans were made to build a church. (SB.)

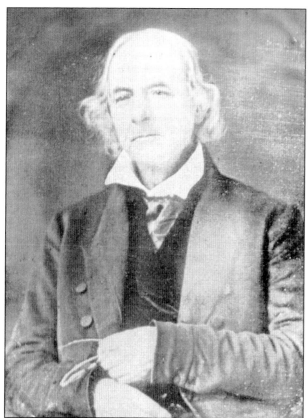

Robert Paterson, the first minister of Hiland Presbyterian Church, was born April 1, 1773. In 1776, he turned his attention to the study of theology, and was ordained in 1801. Looking for a church to preach in, he came across the newly built Hiland church and served as minister from 1807 to 1833. During this time he also was the president of Pittsburgh Academy, which later became the University of Pittsburgh. (HPC.)

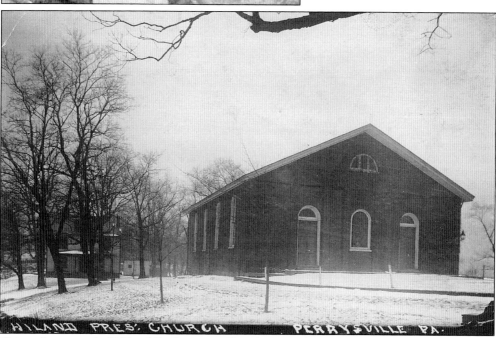

This early postcard of Hiland Presbyterian Church shows the building in its original state. The current church was built in 1836. (HPC.)

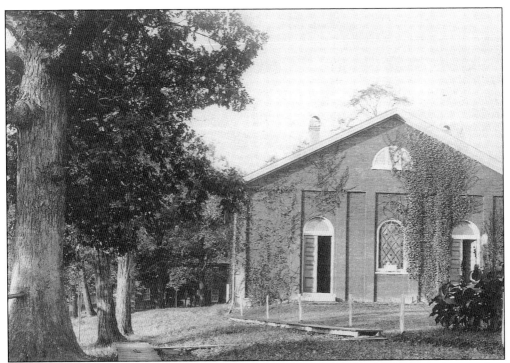

The Hiland Presbyterian Church was originally a tent in 1799. Worshipers would bring their muskets in case of an Indian attack, which was still a common threat in the area at the time. (HPC.)

The property for Hiland Presbyterian Church was chosen due to its easily visible location on the farmlands of Martha Hiland. In this photograph from the early 1910s, the rectory can be seen on the far left. (HPC.)

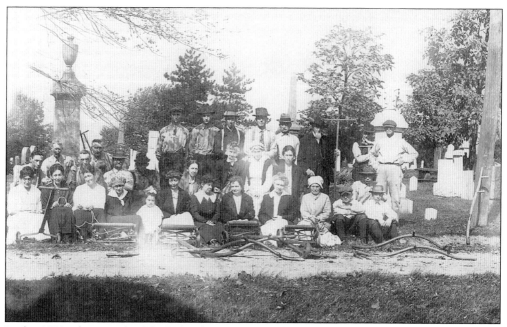

In this 1880s photograph of the Hiland cemetery, members pitch in to clean up the grounds. This image also shows most of the early settlers of Ross Township, including the McKnights, Reels, Criders, Keows, Englishes, Goods, Gasses, Peebleses, Sangrees and Thompsons. One of the first burials at the cemetery was Jacob Weitzel in 1809. The oldest burial was that of John McKnight, who lived to be 101 years old. (HPC.)

This is the inside of Hiland Presbyterian Church in the 1870s. The pews are the very same that are used today. (HPC.)

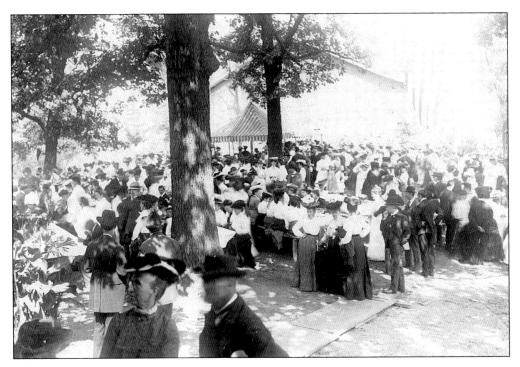

These two photographs depict just how big of an impact Hiland Presbyterian Church had over the years. This party is taking place sometime in the early 1900s. The church's cemetery was an open burial ground, meaning anyone of any denomination could be buried there. This was also the site of many social gatherings that were held during the church's 211 years of service. (Both, HPC.)

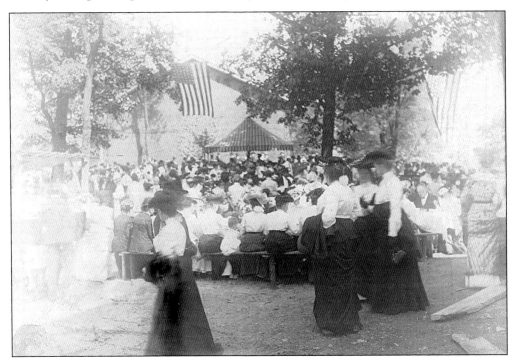

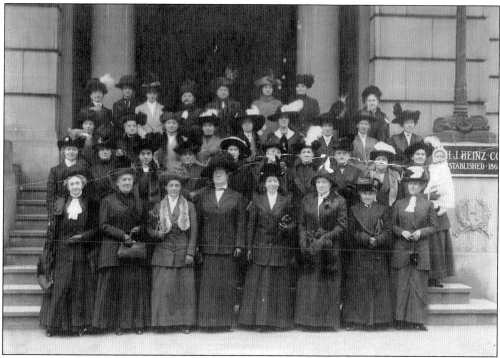

Hiland Presbyterian Church had a Ladies Aid Society, pictured here visiting the H.J. Heinz factory on December 12, 1912. The society was formed during the outbreak of the Civil War. When resources ran out for soldiers, the ladies provided clothes, goods, and nursing care free of charge. (HPC.)

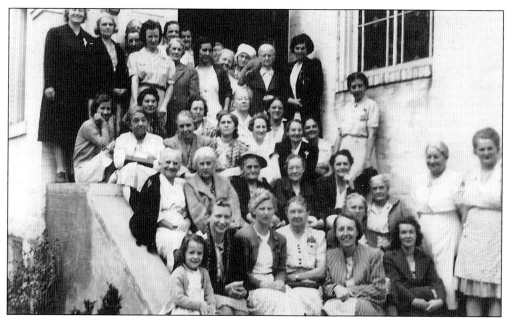

Another photograph of the Ladies Aid Society, this one from 1941, shows them sitting on the steps of the Hiland Presbyterian Church sanctuary. The ladies not only helped out during wartime, but also formed a food bank and helped local Ross Township families in need of aid. (HPC.)

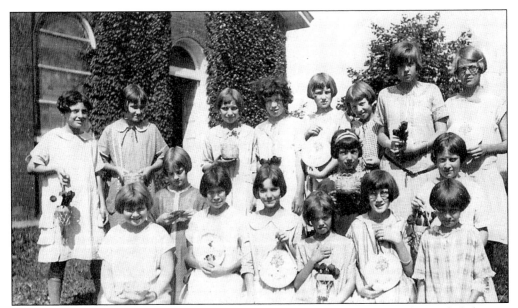

Attached to the original church, an expanded section was added in 1914 that included many large rooms for Sunday school classes, which continue to this day. This photograph shows the daily vocational Bible school class in 1926. (HPC.)

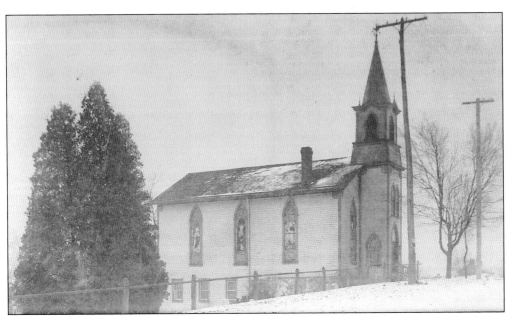

Saint John's Lutheran Church was built in 1867. It was originally called the German Lutheran Church of Perrysville and was the place of worship for many German Ross Township settlers. Next to the church is a very old cemetery that is still in use today. (SB.)

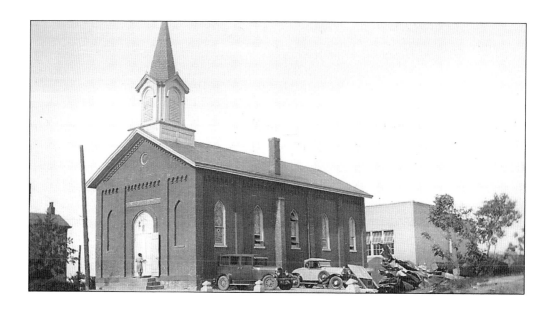

In June 1864, Bishop Michael Domenec bought two lots of land in Perrysville for $400. A Catholic church was built and on Sunday, October 6, 1867, the church was dedicated and open for mass. Some of the early members were the Good, Decker, Keown, and Keating families. Catherine Ivory was the first child baptized there and the first marriage took place between John Burch and Catherine Baley in 1867. (Both, DM.)

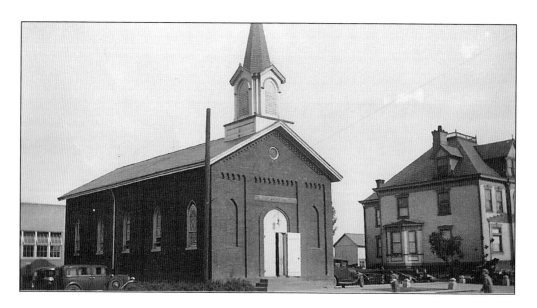

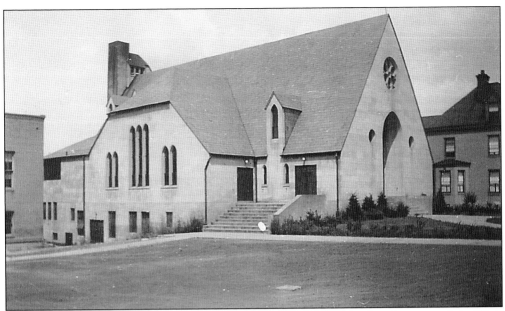

As Ross Township grew in size, the parish of Saint Teresa of Avila church grew with it. Work began on November 29, 1934, to build a larger church, which still stands today as a rental facility and the scene of many graduation and wedding parties. (DM.)

The rectory for Saint Teresa of Avila was built in 1901 and was originally located farther back from Perry Highway. By 1906, the rectory was converted temporarily into a small schoolhouse and was eventually moved to where it stands today. (DM.)

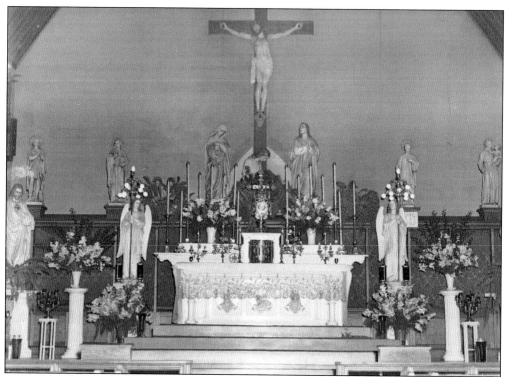

This interior photograph of the second Saint Teresa of Avila church was taken in 1938. The church remained active until a third church was built in 1983. (DM.)

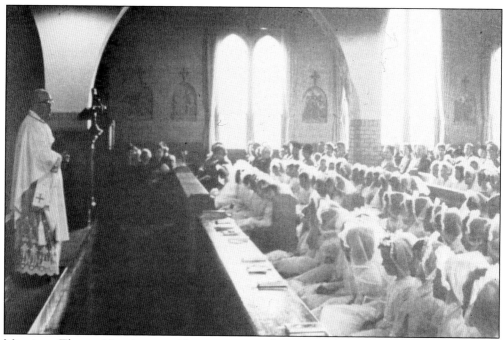

Monsignor Thomas Henninger presides over a group of young girls during their first holy communion in 1962. (DM.)

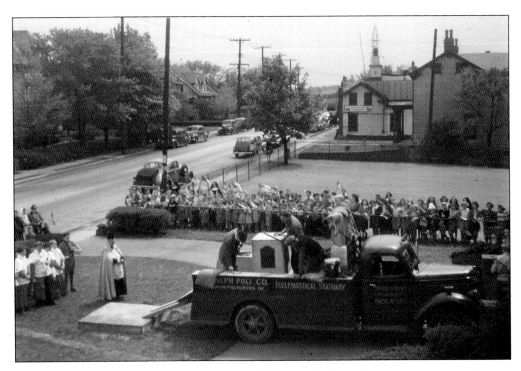

These two photographs show the dedication of the *Sacred Heart of Jesus* statue at Saint Teresa of Avila in May 1946. The most interesting thing in these photographs is what the surrounding Perrysville area looked like. On the upper right is the Perrysville Volunteer Fire Company and in the middle of the photograph is a house now owned by North Hills Printing. Note the many trees lining the street; now there are no trees along the road. (Both, DM.)

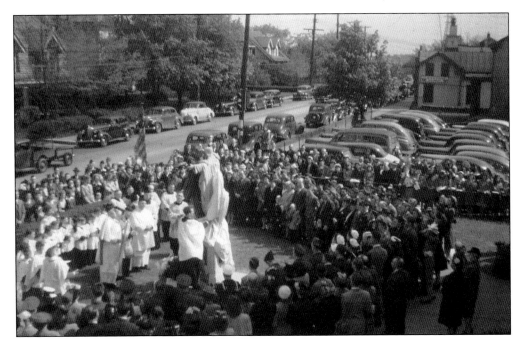

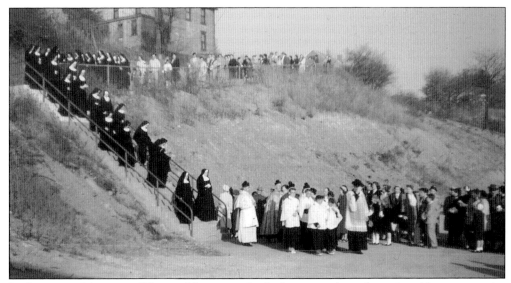

In this scene, Monsignor Thomas Henninger leads the sisters down from the old rectory to the spot where the new school was going to be built. (DM.)

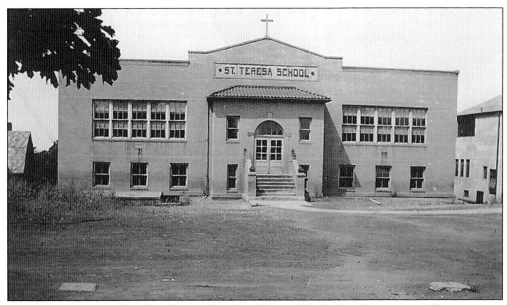

In 1920, a half acre was bought adjoining the Saint Teresa of Avila church property and construction of a new school began in 1924. The school had all the modern conveniences including steam heat, drinking fountains, modern bathrooms, and even an auditorium with a piano. (DM.)

This is a photograph of the very first graduating class of Saint Teresa of Avila School in 1926. The students remain unidentified, but standing in the last row on the far left is Rev. August G. Schoppol. He was the pastor for 37 years from 1918 to 1955. (DM.)

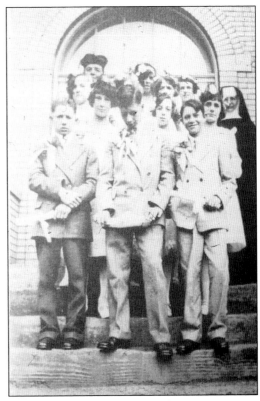

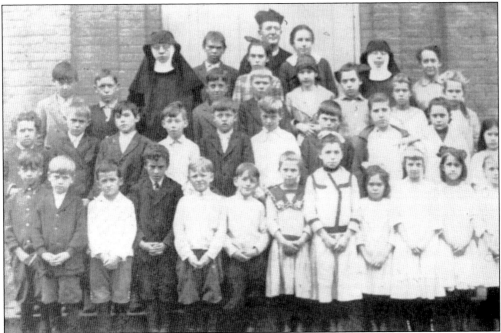

In this early photograph from Saint Teresa of Avila School in 1914, the children pictured are the sons and daughters of the original founders of Perrysville. Some of the children were from the Dempsey, Devlin, Fischer, Jenny, Irlbacher, Rebel, and Scheller families. (DM.)

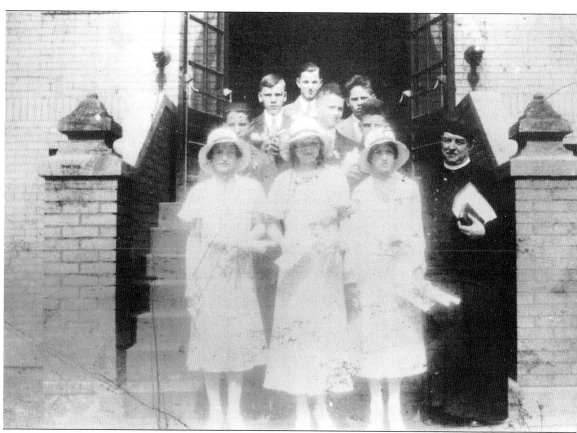

In this early photograph of another graduating class of Saint Teresa of Avila School, Father August G. Schoppol proudly stands with his students at the front entrance. Schoppol was born on December 7, 1881, in Höchst, Frankfurt, Germany. He immigrated with his family in 1888 and soon became close friends with a pastor of Saint Joseph's in Mount Oliver. After graduating from Saint Vincent College in Latrobe, he eventually became the pastor of Saint Teresa of Avila in 1918. Schoppol did not believe in debt, so through his careful ingenuity he raised more than $50,000 to build a larger church on Perry Highway. He was a pillar of the early Perrysville community and remained so until his death on November 21, 1955. (MSC.)

Five

FARMS, BARNS, AND HOMESTEADS

This photograph features the old Rebel family farm, located along McKnight Road near where the post office is today. Notice the small light-colored path in the middle of the photograph, which is an early version of McKnight Road. (MSC.)

When Rupert Fischer first came to America at 16, he stayed with his uncle Joseph Veith. He soon got a job working at the Heintz dairy. There, he met Mr. Kroeger, who was the tax collector between Perrysville and Wexford. He needed help collecting taxes and soon hired Fischer to be his assistant and also to do some farm work for him. The land adjacent to the Kroeger farm was owned by the Brunners, and this is how Fischer met his future wife, Catherine. Soon after they were married, they purchased a large farm of 58 acres along McKnight Road. (Both, DM.)

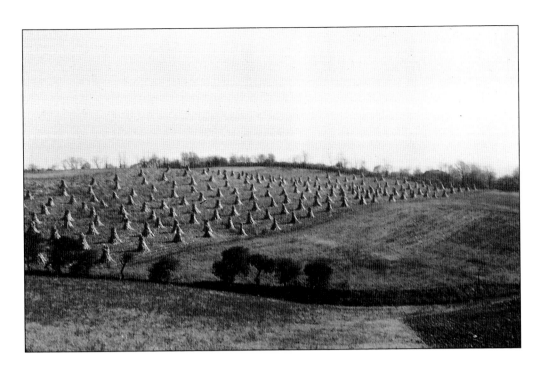

The Fischer family bought its farm in 1902 and continued to own it until 1943. The photograph above shows the many haystacks that were kept in the field where the Guardian Self Storage facility sits today next to Ross Park Mall. The old Fischer farm's entrance was a little farther down the road from Brown's Lane and was directly behind the current McDonald's and Woodhawk Club apartments. The road at that time continued until it met with McIntyre Road. (Both, DM.)

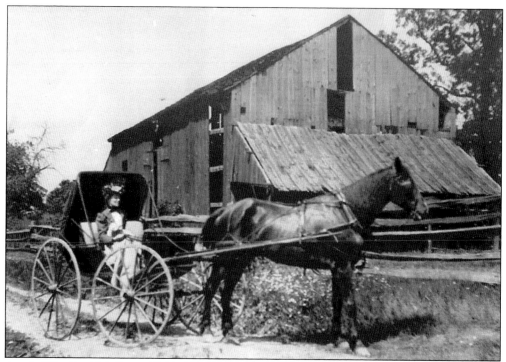

Annie Eliza Reel McGuire (1834–1911) is pictured here riding in a carriage around the 1860s. The barn in the background was Casper Reel's old barn, which was later torn down; it was on land that is now the property of Highland Country Club. Reel's second home was located were the clubhouse now stands and has been recently turned into a restaurant. (JR.)

Traveling down Gass Road in the early 1900s, one would run directly into this farm on Courtney Mill Road. This is an early photograph of David Reel's old barns on his land. (JR.)

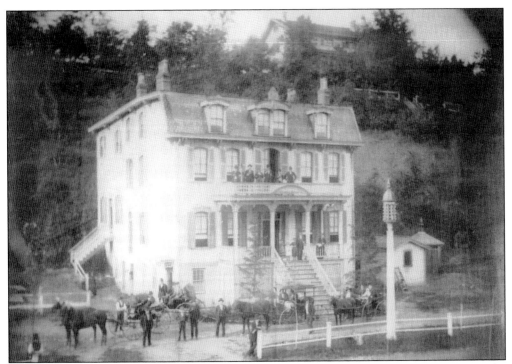

Above, the famous Evergreen Hotel is shown during a celebration of its opening in 1874. The hotel was originally built by Matthew Cridge, who owned and operated the early Evergreen Passenger Railroad, which ran from the corner of the hotel through Millvale to Bennet's Station at the edge of the river. Above the hotel, on the hillside, was Evergreen Hamlet, a small utopian society that was self sustaining and offered an escape from the noise and smoke of Pittsburgh. In 1851, the society built four large houses that are still standing. Their magnificent architecture and historic value have warranted a spot on the National Register of Historic Places. Evergreen Hamlet has such an interesting history that it could fill a book by itself. The photograph below shows Evergreen Hotel in its current abandoned state. (Both, RHS.)

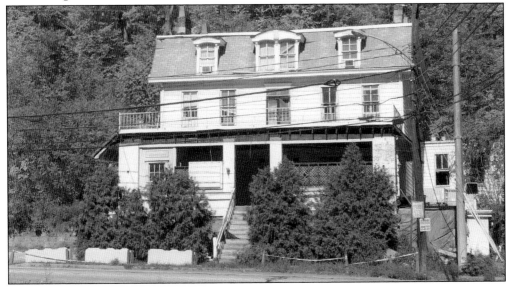

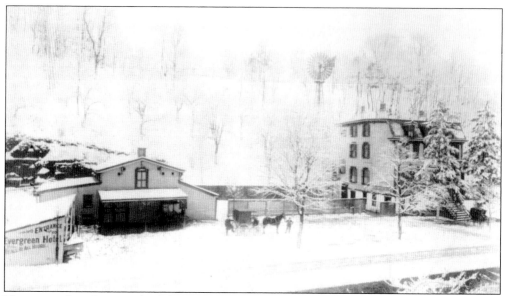

Here is another photograph of the Evergreen Hotel from the late 1880s. It gained attention as a speakeasy during Prohibition and as a bordello, and had separate entrances for women and men. The building, which remains almost identical to when it was first built, has been the scene of many good times and many bad times There have been at least three confirmed murders since the 1890s, multiple police raids from the 1920s through the 2000s, and many hauntings have been reported as well. (RHS.)

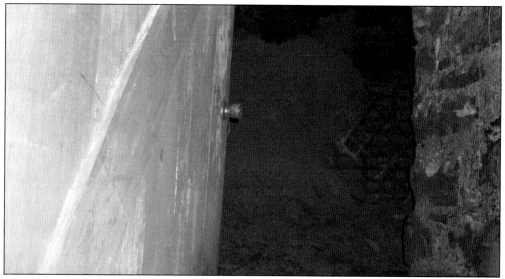

This photograph was taken during the presale of the hotel at a public auction in October 2009. While inside the old bar, the author found a hidden latch tucked underneath and inside the bar cabinets. After struggling to open it, a large door appeared that was locked from the other side. After getting the door open, the author and others crawled inside and discovered an old, bricked-up tunnel leading to Evergreen Hamlet above. This must have been used during Prohibition for the hiding of certain goods, for many tin cups and old whiskey bottles were laying about. The passageway was rumored to have been a hideaway for runaway slaves, but this could not be true since the hotel was built 10 years after the Civil War. (Author's collection.)

This is the Beverly Hills Hotel, originally a large mansion called "Green Gables" that was built by the Wood family in 1876. It was later bought by Harry Dipple around 1890 and was renamed the Beverly Hills Hotel because of its grand scale and comparison to the famed hotel with the similar name in California. It became a famous nightclub and dinner theater and even featured a young Frank Sinatra before a fire occurred on May 20, 1975, which left the hotel in its current state of ruins. (RHS.)

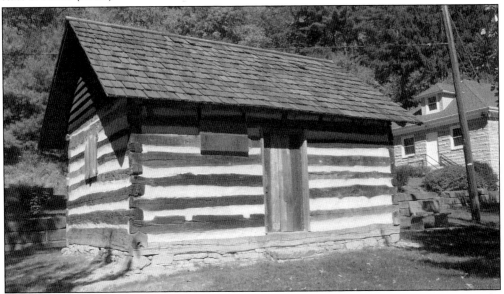

The Schlag log cabin used to sit high up on the original farmland of Jacob Schlag along McKnight Road. The original farm was between Thompson Run Road and McKnight Road, just north of Seibert Road. The 210-year-old cabin was saved from destruction by the efforts of Sandy Brown and others, and it was relocated to Ross Township's Evergreen Park. (Author's collection.)

The John Graham house was built in 1824 on a plot of Depreciation Land granted to Revolutionary War soldier Joseph Caskey. The house was later bought by Stephan Affolder, who lived a long life at his old family farm along Goldsmith Road. He bought this house and property for his son Samuel Affolder as a wedding gift in 1886. The house changed hands many times and is now in the possession of the Santillo family, which has preserved it in its almost original state. It is currently a Pittsburgh Historic Landmark at 208 Twin Oaks Drive. (DMS.)

The Jacob Weitzel estate was built in 1814 by the family of Revolutionary War soldier Jacob Weitzel Sr., who died in 1809 and left provisions in his will to have a house built in this location for his very large family. The property stretched from where it is today to past the McCandless Township line. Many of the Weitzel children lived their lives on this land until Jacob Weitzel Jr. inherited the house with his wife, Jane, sometime around the early 1820s. The house sits abandoned today and is the feature of many ghost stories in Ross Township. Compelling evidence has brought some to believe that the house is still occupied by the long deceased Weitzel family. The house is a Pittsburgh Historic Landmark and was threatened with demolition until the author stepped in to save it. (Author's collection.)

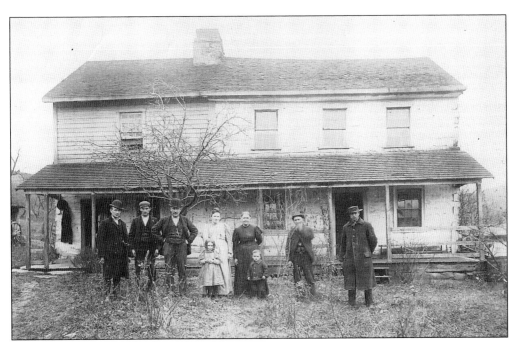

John Fairley was born on January 23, 1779, in Ireland and immigrated to America with his wife in 1798. In 1805, he purchased 429 acres from George Wallace, the first judge of Allegheny County. Soon after, he began gathering lumber from the forest on his property and started construction on his house. It was completed on September 10, 1806, making it the oldest house in the township and one of the oldest in all of Allegheny County. The above picture depicts the house in 1896 with some of the Fairley family in front. Family members possibly pictured in this photograph are John Fairley III, his wife, Susan, and their son Thomas Fairley. The below photograph was taken in September 1931. The house still stands today at 365 Jacks Run Road. (Both, TS.)

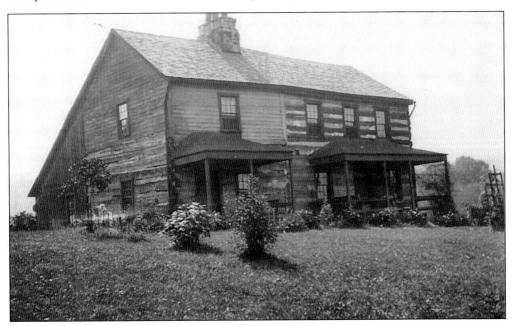

This is the home that was built by David Reel, son of Casper Reel, in July 1852. David was born on June 22, 1795. He and his twin brother were the first white children born north of Pittsburgh. David engaged in the shipment of goods from Pittsburgh to Philadelphia and became very successful and well respected for this service. He also was the first person to bring Methodism to Western Pennsylvania. He originally built a log house and rebuilt it later using the finest wood available. The house stood for 133 years at 173 Courtney Mill Road until the construction of Interstate 279 caused it to be demolished. (JR.)

Most people who live in Ross Township today hear stories from elders about the old farms that went up and down McKnight Road and Perry Highway. This is truly hard to believe due to the various developments that occurred over the last 50 years. This photograph represents the farm life that was once common all over the township. Farmers along McKnight not only had hogs, but also horses, cows, chickens, roosters, goats, lambs, turkeys, plows, tractors, and sometimes even moonshine. (JR.)

Six

NAVIGATING THE PATHWAYS OF THE PAST

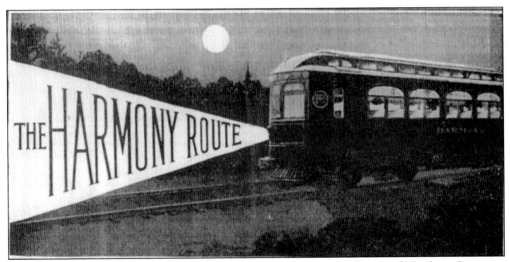

This early advertisement for the Pittsburgh, Harmony, Butler, and New Castle Railway Company features the Harmony Route, which carried passengers from downtown Pittsburgh to many different places. The Harmony Route's first day of operation was November 14, 1908. (JM.)

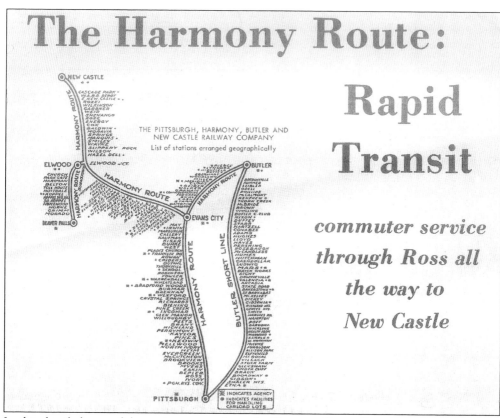

The Harmony Route: Rapid Transit

commuter service through Ross all the way to New Castle

In this detailed map of the various stops along the Harmony Route, Ross Township is featured prominently. The first stop out of Pittsburgh was Ivory Avenue. The trolley generally stopped at popular farms that were convenient locations. After Ivory Avenue, the stops were, in order, Ross Junction, Bepler farm, Eakin farm, Myers farm, Brooks farm, Brookview farm, McCutcheon, and Evergreen. From there, the trolley turned up what is now Babcock Boulevard to the Heim farm across from Seibert Road, then went on to stops at North Ivory, Mellwood (the former Jergels restaurant), and then to the station at Keown. The image below shows the Standard No. C-60 car, which could safely operate at a speed of almost 75 miles per hour. (Both, JM.)

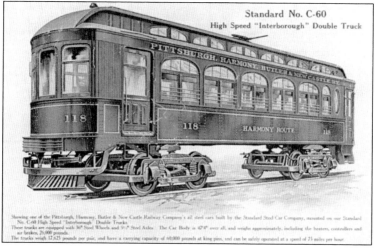

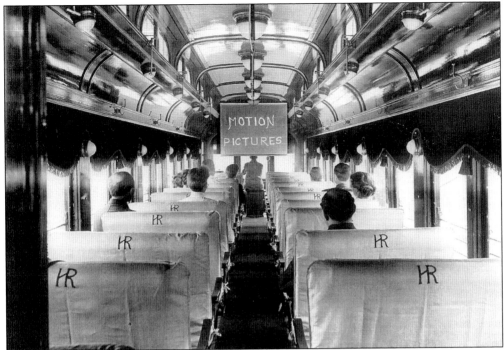

These two rare photographs show the "Harmony Party Car." Its seats are covered with damask slips with the Harmony Route monogram. This car was one-of-a-kind in its time. It featured a 35 millimeter Motiograph projector housed in the roof dome that was lowered on elevator guides to adjust the proper height for motion pictures. By the time these photographs were taken, sometime around the 1920s, the car was capable of carrying 50 passengers, and was also popular for bridge parties. (Both, JM.)

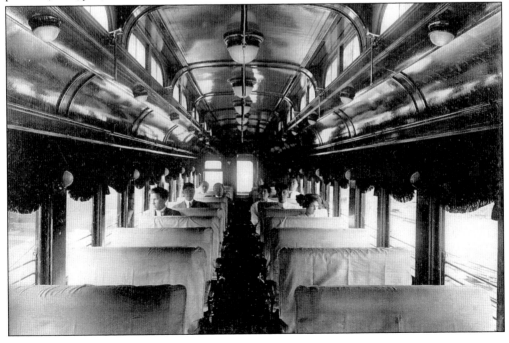

This great photograph, taken in 1931, features the car *Ajax*. In the back row, from left to right, are Ralph Cox Jr., Paul Stauffer, Kenneth Hartung, Andrew Cox, Bill Reetz, and Jerry Cox. Sitting in the front row are two unidentified neighborhood sisters. The neighborhood kids found an old tool car in a shed behind the Keown Station and brought it home where an unknown mechanic installed a Model T engine on it. The car could go as fast as 35 miles per hour. Notice Ralph Cox filling *Ajax* with gasoline. They fashioned a light on the front and rode the car all the way up to Bradford Woods. This photograph was taken above Nelson Run Road next to where McKnight Road cuts through today. (JM.)

This photograph, taken sometime around 1920, features a Model T repair shop that was located above Cemetery Lane. At that time, a special driver's license could be given to children as young as 12 years old as long as there was a good reason for it. (JM.)

This photograph of the intersection of Cemetery Lane and Perry Highway was taken sometime in the late 1940s. The building in the background was the Samuel Hamilton High School, which, by 1922, was offered to students as an alternative to Perry High School. Today, one can still see the Samuel Hamilton name etched into the stone above the entrance. The school was closed in 1983. (JM.)

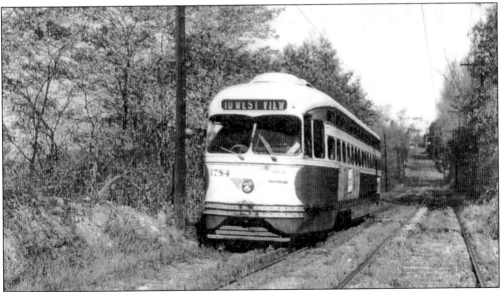

This is the West View car No. 1784 traveling along the heavily forested upper part of the Harmony Line, along the Ross Junction. Although the car reads "West View," it is interesting to note that by the time this photograph was taken, the Harmony Route was now part of a more localized Allegheny, Bellevue, and Perrysville route, which strictly ran through Bellevue, West View, and Perrysville. (JM.)

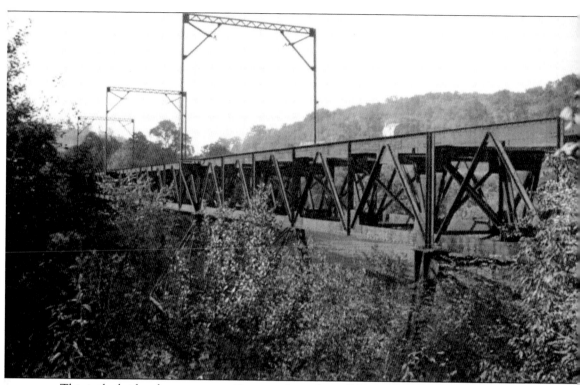

This is the bridge that ran across Cemetery Lane from 1908 until 1936. The bridge was 300 feet in length and almost 50 feet in height. Looking closely today, one can still see the bridge supports along both sides of the lower entrance to the road. After the Harmony Short Line ceased operations in 1931, neighborhood kids used to climb up and walk across the beams. (JM.)

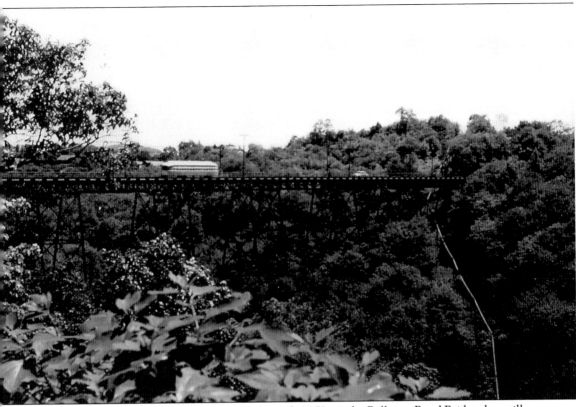

Seen in this photograph, taken sometime in the early 1950s, is the Bellevue Road Bridge that still runs above Interstate 279. This was the only connection between Bellevue and Ross Township by trolley. It could also be used by automobiles. (JM.)

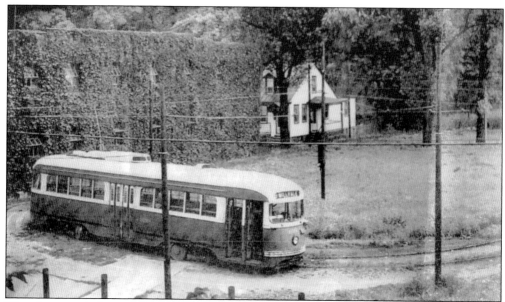

This photograph shows the PCC 1698 as it makes a tight turn around the Millvale loop near the intersection of Babcock and Evergreen Roads. This streetcar line was converted to bus routes after its closure on Labor Day 1952. (JM.)

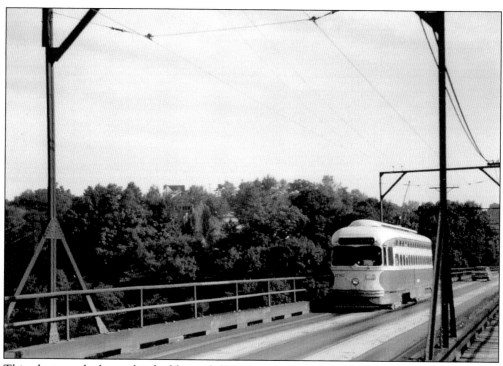

This photograph shows the double track line that ran across the Bellevue Road Bridge. After spending a long day at West View Park, passengers could easily catch a ride on one of these trolleys back into Perrysville or Bellevue. Notice all of the electrical wiring that had to be in place for these cars to run. (JM.)

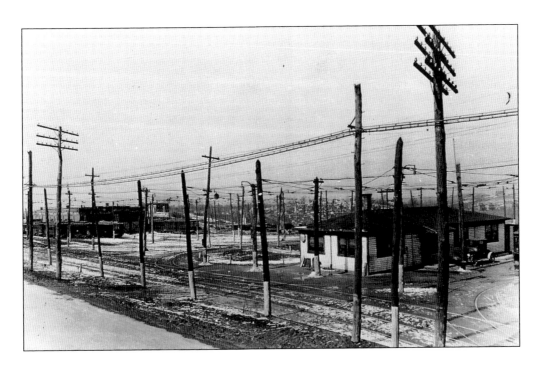

Both of these photographs depict the early Ross Township garage on Perry Highway. This was the car house for the Allegheny, Bellevue, and Perrysville Railroad Company until its closing in 1964. The Port Authority Transit (PAT) took control and slowly converted all of the tracks and routes to a more modern bus system. This is still the garage used by the port authority today along the upper portion of Perry Highway next to the Pittsburgh city line. (Both, JM.)

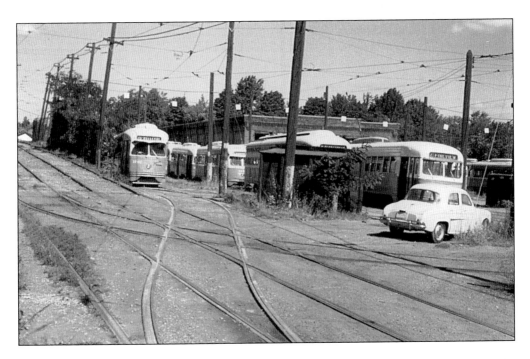

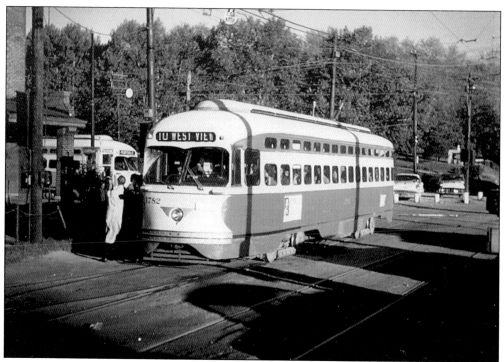

This is a photograph of the trolley's last day in existence, September 5, 1964. It was taken at the car house located near the Port Authority Transit (PAT) bus station today. (JM.)

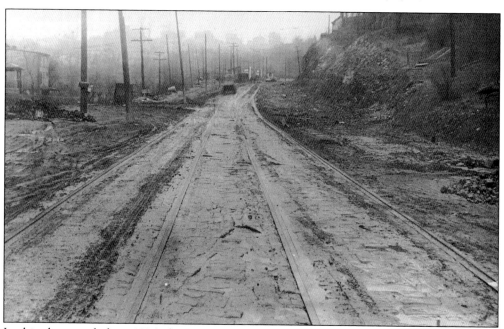

In this photograph from 1926, the Harmony short car tracks traveling up People's Plank Road can be seen. The Brookview stop was on the right and at the top of the hill was the Ivory stop. The Evergreen Hotel was located behind and to the right of the spot where this photograph was taken. (RHS.)

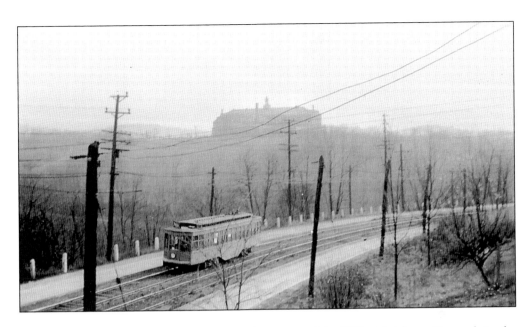

The above photograph, taken in the 1920s, features car No. 5529 with Mount Nazareth in the background. The congregation of the Sisters of the Holy Family of Nazareth was begun in Rome in 1875 by Frances Siedliska. A local organization of the Sisters of the Holy Family of Nazareth purchased 42 acres along Bellevue Road in 1924. In 1927, they constructed an administration building and school. After closing the school in 1970, the Sisters started a new ministry that the author attended in 1986. (Both, JM.)

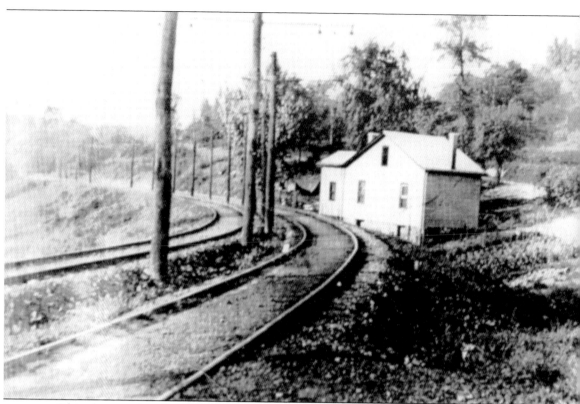

This photograph, taken in 1909, shows an early Ivory stop near Nelson Run Road. The house still stands today on the top of Nelson Run. To the far left, McKnight Road rungs through the valley today. (JM.)

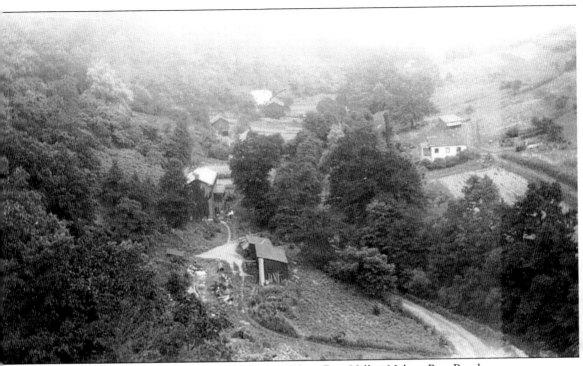

This photograph from the early 1910s shows the Nelson Run Valley. Nelson Run Road was one of the oldest roads in the township and is so well preserved today that one might get lost in time with just how rural it still looks. In the top middle of the photograph is the Brooks family barn, which sadly was crushed by a heavy snowfall in 2010. Thomas Brooks, the great great grandson of the McKnight, Nelson, Crider, and Brook families, is now rebuilding the barn from scratch using the original materials his ancestors used when they built it in the 1850s. (TB.)

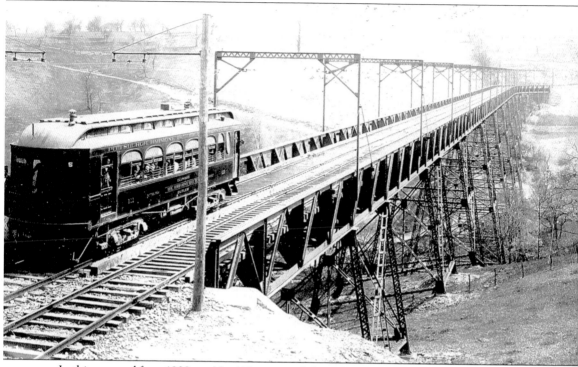

In this postcard from 1908, car No. 111 is stopped along the Renfer Bridge to pose for a photograph. The Renfer Bridge was the first bridge built north of Pittsburgh and was completed in November 1908. It was an estimated 1,000 feet long and 160 feet above Nelson Run Road. To the back right of the photograph would be Renfer Street today. (JM.)

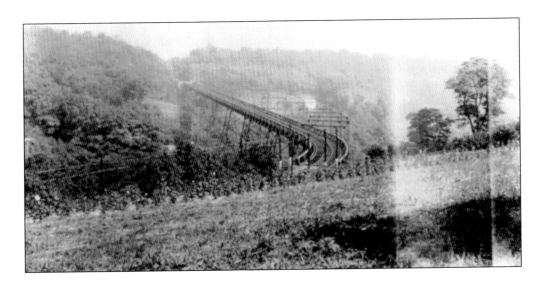

Pictured in these two 1908 photographs is the Render Bridge. Above is the bridge from the Peterman farm on Nelson Run Road. Below is a more direct view looking down the Harmony Short Line. It was about .75 miles of a mostly downhill grade to the Cemetery Lane Bridge. The Render Bridge was lost due to the construction of McKnight Road in April 1936. (Above, GM; below, JM.)

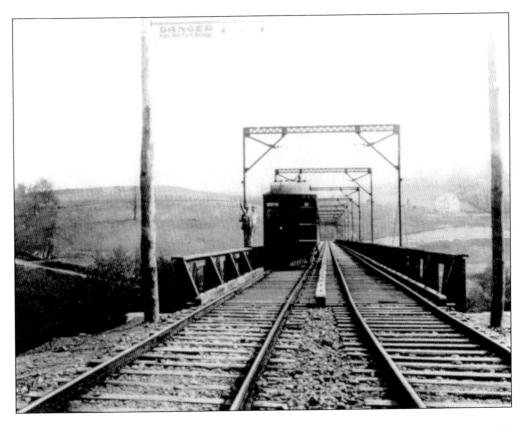

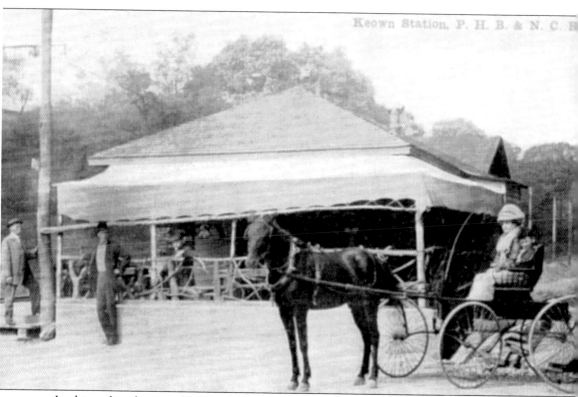

In this earliest known photograph of the Keown Station, an unidentified mother and her son begin to embark on their journey down Three Degree Road. Construction was completed for the Pittsburgh, Harmony, Butler, and New Castle Railroad on Thanksgiving Day 1908. At the far right, an early Babcock Boulevard is visible. (JM.)

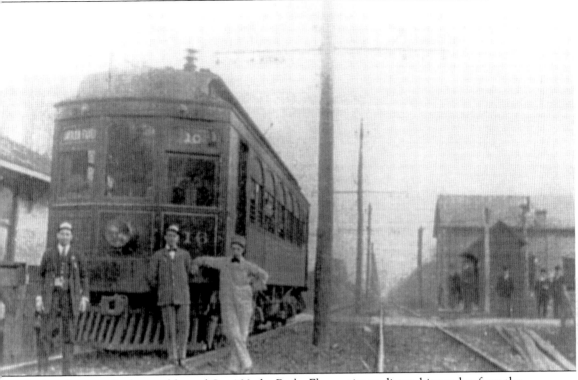

In this photograph, the northbound Car 166, the *Butler Flyer*, waits on dispatching orders from the Keown Station. Fare from Pittsburgh to Butler was $1.25 round-trip at the time this photograph was taken. Looking straight down the road in front is Babcock Boulevard, and the substation for the railroad is on the right. (JM.)

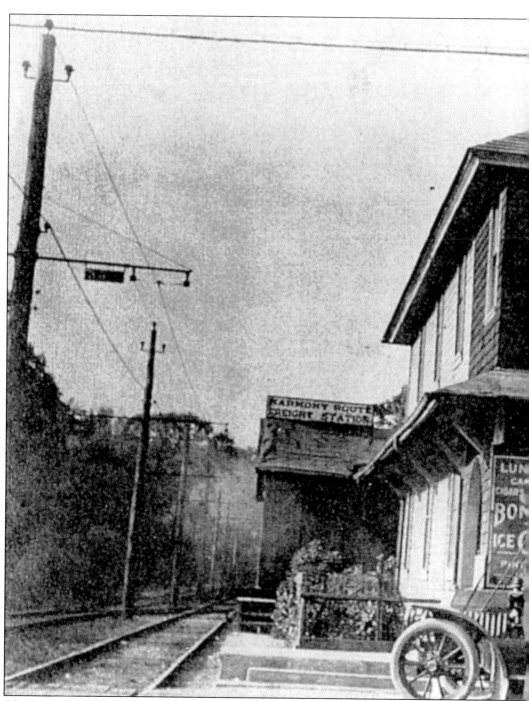

This is the Keown Station as most would have remembered. This 1920s scene looks north behind what is now Northway Car Wash. The station featured a small general store that sold ice cream, tobacco, and candy. It was named Keown after the prominent Keown family that lived near the property. John Keown was born in Ireland in 1800 and moved to America by the time he was 19 years old. While in Pittsburgh, he became a brick manufacturer and a distinguished man in his day. He became the first councilman of Allegheny City and also held a position of officer on the

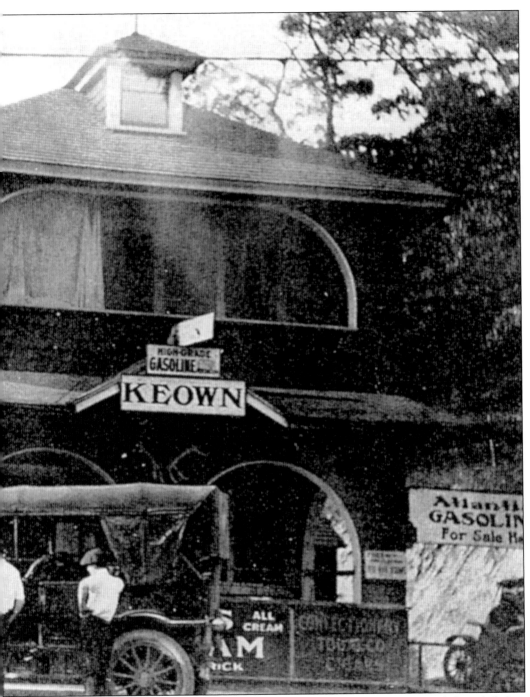

education board. He moved to Ross Township in 1857 and married Susan Good. Susan's father, Balthazar Good, was one of the first settlers and homeowners in Ross. He also built a large tavern, which burned down on September 10, 1856. It was later given to John Keown to rebuild. He became a postmaster and fathered nine children, one of whom, William, continued the proprietorship of the tavern. The Keown Station and ticket office was later run by Charles Nagel. (JM.)

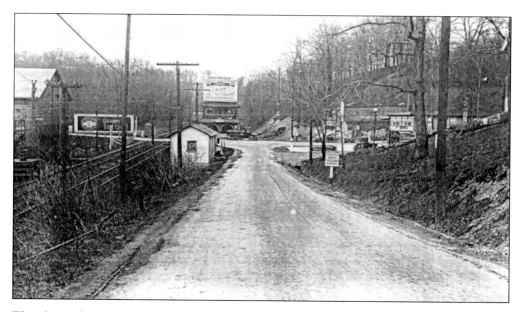

The above photograph looks north down Babcock Boulevard in the 1920s. The building in the middle is the Keown Station, which is now the Northway Car Wash. The building to the far left of both photographs was the Keown Substation. It provided 1,200 volts of power to run the trolleys from here to New Castle. The substation later became a dry cleaning business and is currently owned by Safe and Sound Electronics. It is truly amazing that this location almost remains the same. (Both, JM.)

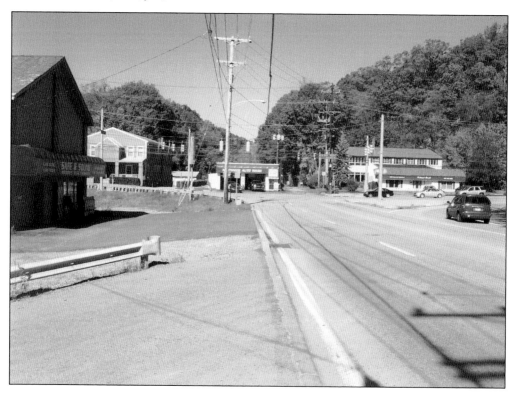

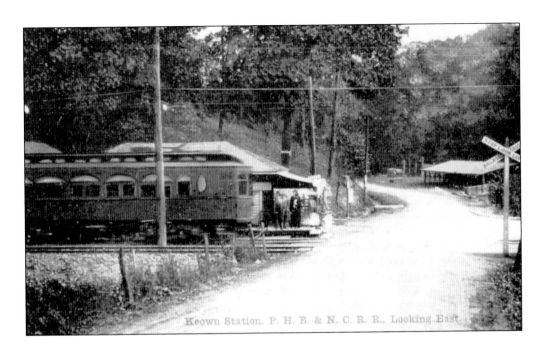

The above photograph features an early Keown Station around 1908 and looks east down Three Degree Road toward the GetGo gas station of today. To the left, a train is pulling in to turn around and run south on the track about 75 meters behind the station. The photograph below was taken on August 4, 1927. Keown Station was also a popular stop for local children to grab fresh ice cream on a hot summer day. (Above, JM; below, RHS.)

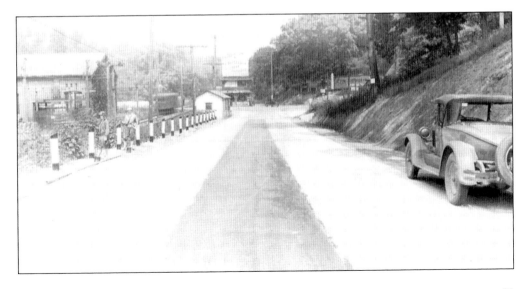

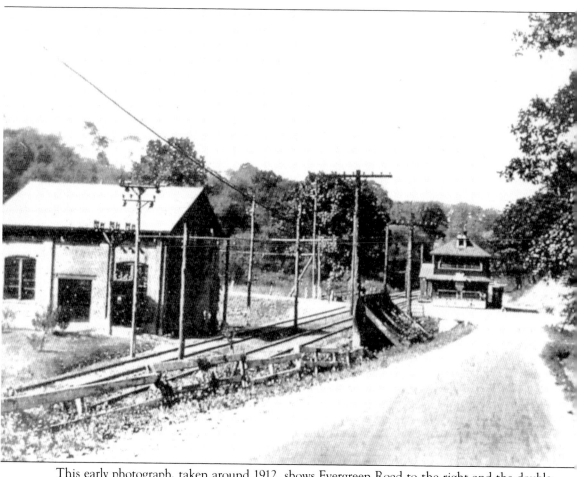

This early photograph, taken around 1912, shows Evergreen Road to the right and the double tracks of the Harmony Route line to the left. The interesting thing about this photograph is the location of the tracks. Babcock Boulevard as it is known today did not exist until after the Harmony Route line closed in 1931. (JM.)

The Keown Station was one of the busiest and most well known stations in all of Western Pennsylvania. It was the first station outside of Pittsburgh and was the connection to the north. The building on the right was the Atlantic Motor Oil Gas Station and to the left was a shed for supplies used by the Keown Substation. (JM.)

Shown in these two photographs is Evergreen Road. The photograph above shows where Evergreen Road and Babcock Boulevard split today. Notice to the right of the photograph that Babcock Boulevard did not exist at the time this photograph was taken. The photograph below is of Evergreen Road from across the street in Evergreen Community Park looking north. (Both, JM.)

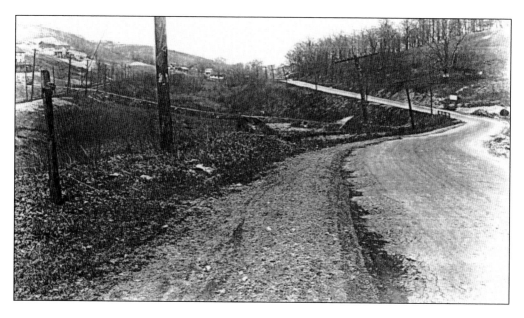

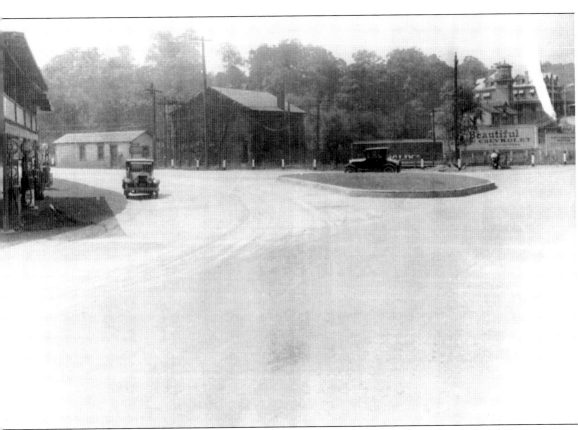

In this photograph taken on August 4, 1927, one can clearly see west up Three Degree Road. An interesting item in this photograph is the old billboard, which is still standing and being used today. The building on the far left was a gas station that was later turned into a mattress store and burned down in 2009. (RHS.)

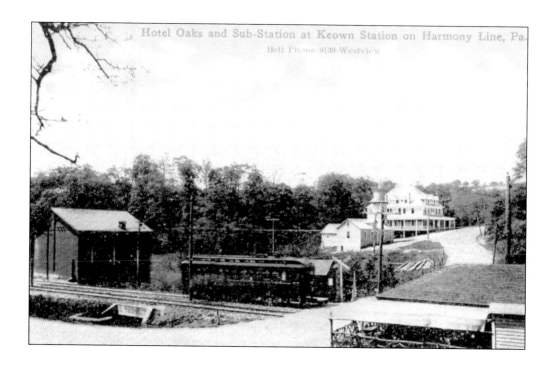

Hotel Oaks and Sub-Station at Keown Station on Harmony Line, Pa.
Bell Phone 9139-Westview

These are before and after photographs of Three Degree Road. The above photograph, taken in 1912, shows the magnificent Oaks Hotel that was built in 1910. The hotel stood for just 30 years until a fire swept through the building, burning it to the ground on September 30, 1940. The spot where it was located is now an abandoned strip mall where in 1968, Northland Library was originally located. (Above, JM; below, author's collection.)

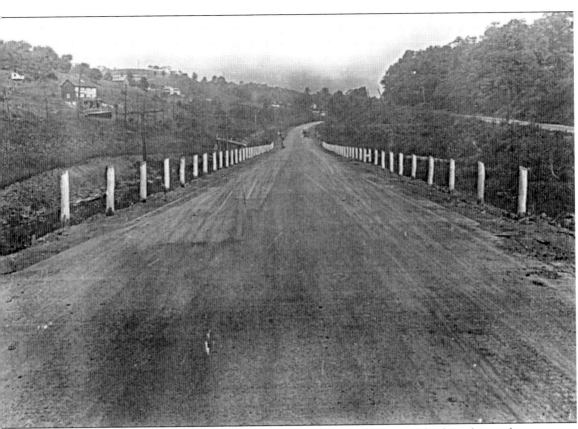

This photograph shows a dirt-covered Babcock Boulevard in the 1930s. To the far right are the Harmony Route tracks. To the left of is where Papa John's and Subway are today. Most of the old Harmony Route line now follows the path of Maple Drive. In the far distance, between the hills, would be Kunzel Road. Before Seibert Road was established, Kunzel Road was the only way to McKnight Road. (JM.)

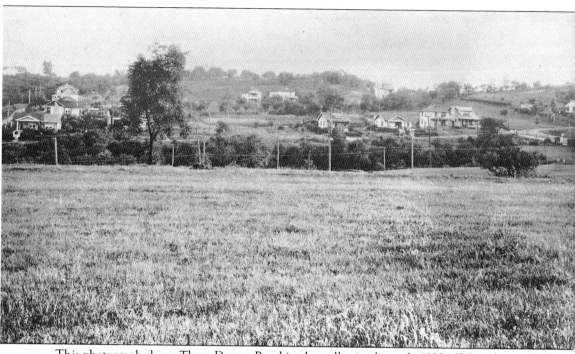

This photograph shows Three Degree Road in the valley in the early 1930s. Taken from a field where the BP gas station is today, one can clearly see Second Avenue to the far left and the Elrose Development Company's barn in the top corner. Notice on the right that Perry Highway did not continue in the same route that it does today. It curved behind the current Dairy Queen and exited at Rebel's Corner. (MSC.)

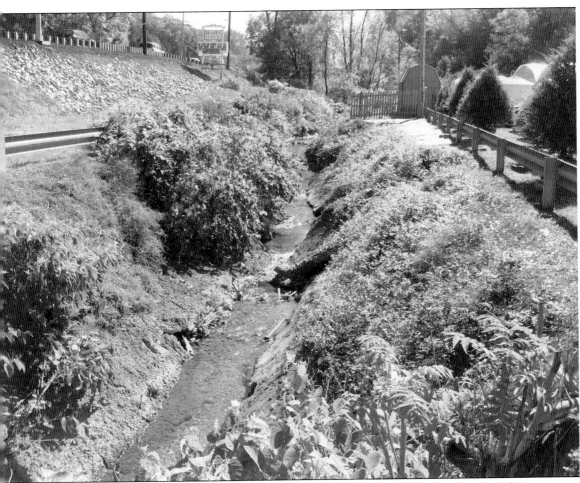

This photograph shows the famous "Girty's Run" that parallels Babcock Boulevard today. This natural creek is famous because of its association with the true legend of the renegade Simon Girty. Sometime after the Revolutionary War, Girty, a well-known traitor to the Americans and an interpreter between the British and Native Americans, fled from Pittsburgh and was trailed throughout Ross Township along this very creek. Some say that the floods of Millvale in recent years were the "curse" of Simon Girty. (Author's collection.)

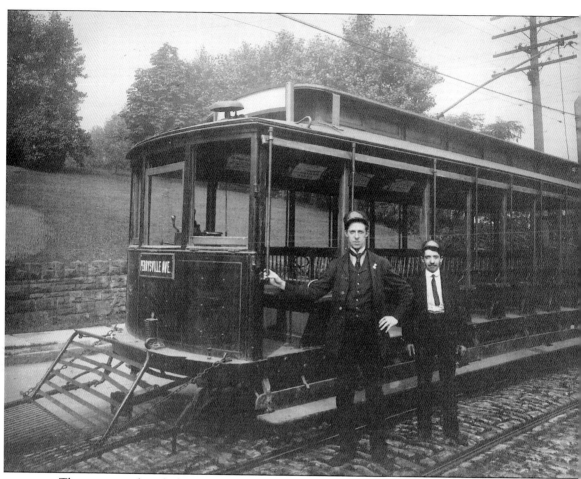

These two unidentified men proudly stand next to their Perrysville cable car. This is what the typical cable car would have looked like if one were riding from North Side to Perrysville. This photograph was taken in the 1910s along Perrysville Avenue near Riverview Park. (RD.)

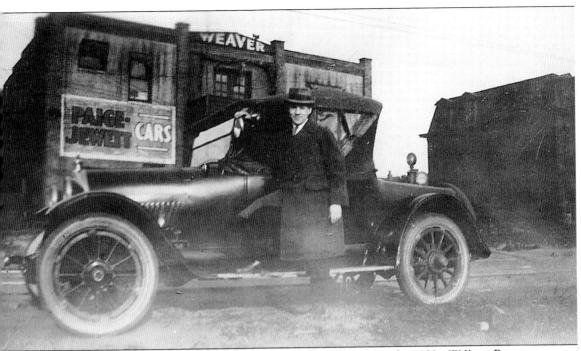

William Brant stands proudly next to his car along Perry Highway in the 1930s. William Brant Sr. was a very successful businessman who started Heiber's general store with Charles Heiber in 1898. His family later went on to build and operate many successful businesses all around the West View area. (RD.)

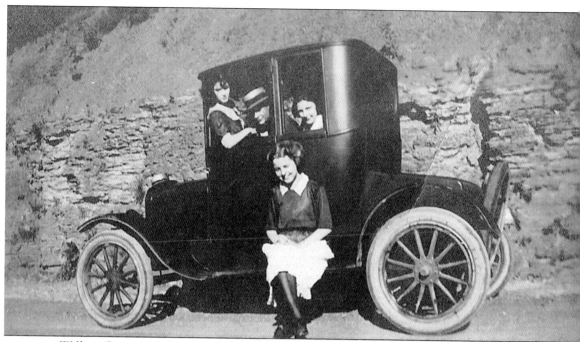

William Brant and three unidentified young women are in his tiny car along Perry Highway sometime in the 1920s. The Brant family started a successful business in building supplies. Brant and his brothers built or assisted in the construction of more than 100 homes in Ross and West View during their long career. (RD.)

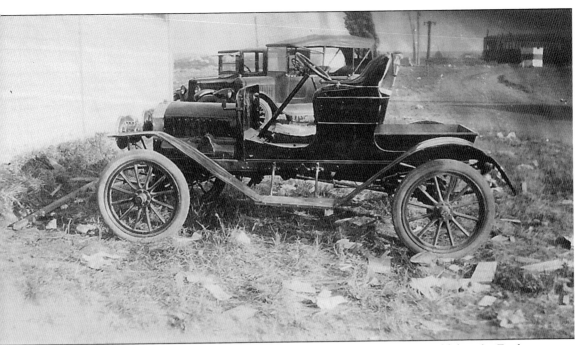

Priced at $850, not only was it the first affordable, mass-produced car in the world, but the Ford Model T—a 1912 model of which is shown above—revolutionized manufacturing and labor in America. This photograph was taken behind Shar's Lane. (RD.)

These unidentified women parked their 1920s Model T along Babcock Boulevard. The sign behind them advertised the Star Bar-B-Que restaurant that used to be located along Babcock Boulevard. (RD.)

This early photograph shows the corner of Sixth Avenue and Rochester Road during the construction of Laurel Gardens in the 1930s. Located on the left would be the current North Hills School District administration building. Early residents were able to put down $5 and build any kind of structure they wanted. All of Laurel Gardens used to be the property of the Heim family. Godfrey Heim sold part of his land in the 1940s to become North Hills High School. Laurel Gardens was unique in the fact that it had its own post office, usually inside someone's residence, until it closed in 1965. (KP.)

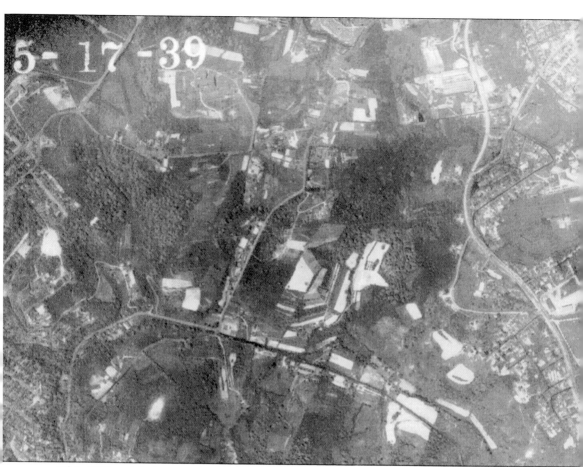

This 1939 aerial photograph clearly shows all the main roads through Ross Township. At the bottom left is Jacks Run Road and Denny Park. The road running north of Jacks Run is Bellevue Road, where, at its peak, the Five Mile Inn was located for more than 100 years. The brighter strip in the middle is Perry Highway, at the very top of which is Martorelli Stadium. At the top right of the photograph is McKnight Road, stopping where it meets Babcock Boulevard running

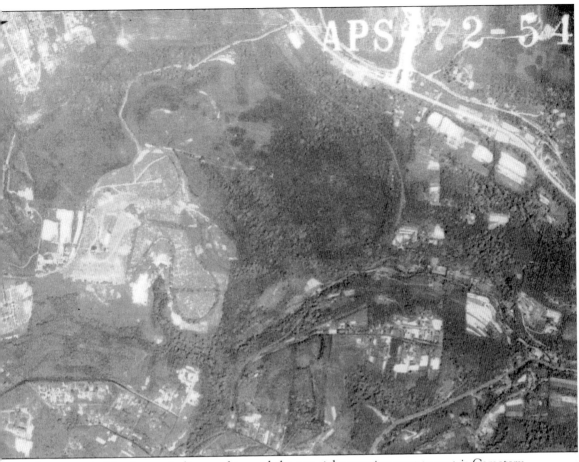

adjacent to it. The long, winding road toward the top right running west to east is Cemetery Lane. An interesting note about Cemetery Lane is that Charles Taze Russell, the founder of the Jehovah's Witness in 1879, is buried under a pyramid-shaped monument in the United Cemetery on that road. (JM.)

FEDERAL WORKS AGENCY
PUBLIC WORKS ADMINISTRATION
JOHN M. CARMODY

FRANKLIN D. ROOSEVELT

McKNIGHT ROAD
SECTION 1
CONSTRUCTED 1939

This small monument at the southeast corner of Seibert and McKnight Roads states that McKnight Road was built in 1939 through the Federal Works Agency during the presidency of Franklin D. Roosevelt. Before it was expanded into a six-lane highway, McKnight Road was a dirt and gravel path that ran from Babcock all the way to Wexford. Many older residents can recall how there were no streetlights on it, and they could drag race for miles on end. (Author's collection.)

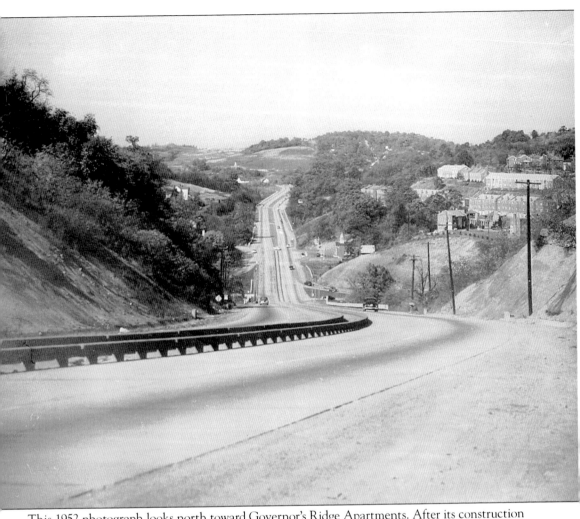

This 1952 photograph looks north toward Governor's Ridge Apartments. After its construction in 1939, many improvements were made to McKnight Road. Here, there is an early guardrail in place. The spot in the middle is now the site of Ross Park Mall. (RHS.)

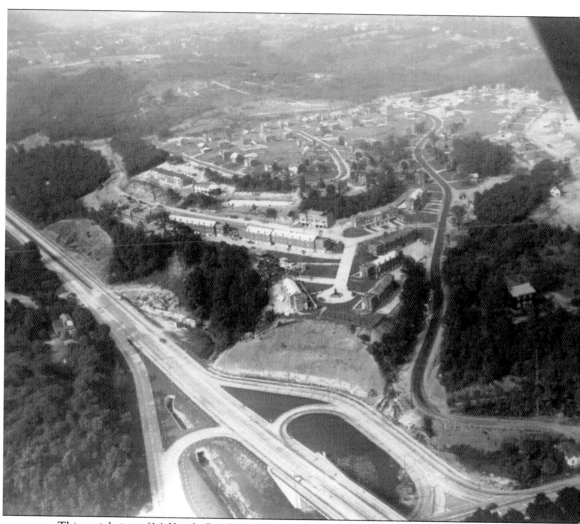

This aerial view of McKnight Road, taken in 1948, shows the newly constructed McKnight Village. In the far distance in the middle is a faint path that was once used as an airstrip to transport weapons from Flaig's Lodge and Gun Club, which was rumored to have connections to the Nazi party during World War II. At the bottom right is Rico's restaurant. (RHS.)

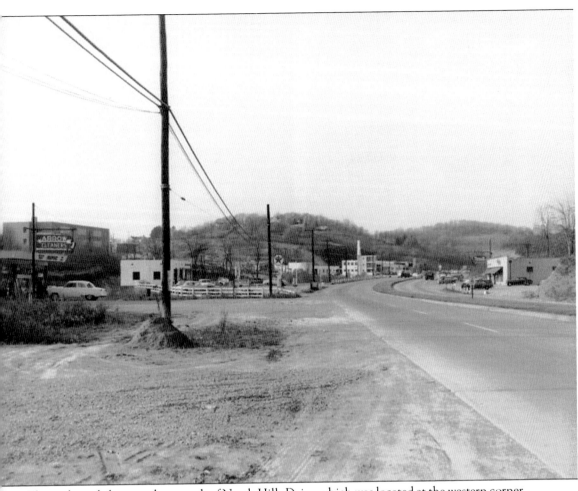

This is the only known photograph of North Hills Dairy, which was located at the western corner of Seibert and McKnight Roads. It was the second business on McKnight Road and was very popular, serving more than 7,000 customers in the North Hills area. In the upper left corner is Saint Sebastian's School and Church, built in 1953. The most interesting thing in the photograph is the vacant lot in the front left—the location of the very first McDonald's in Western Pennsylvania in 1957. A young entrepreneur named James Delligatii was working late in the kitchen of this McDonald's trying to invent something unique that he could sell. He put two all-beef patties, special sauce, lettuce, cheese, pickles, and onions on a toasted sesame seed bun and called it the "Big Mac." This historical event will forever put Ross Township on the map. (RHS.)

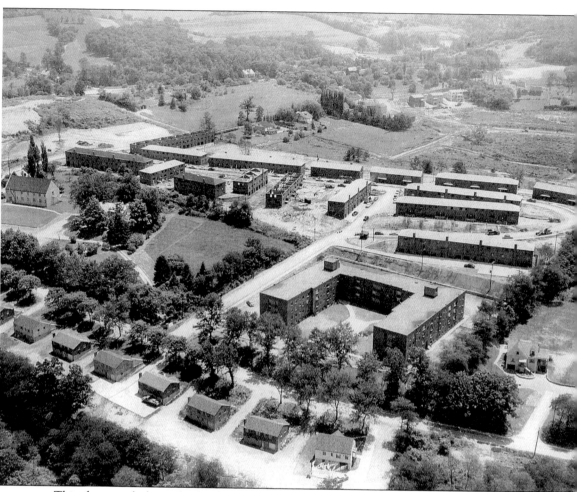

This photograph shows the development of the Chapel Hill townhouse complex, which is located on Browns Lane. To the far right, Christ Episcopal Church can also be seen. In 1952, the year this photograph was taken, new developments started up all around Ross Township. At the top is the location where the Mews townhomes were eventually built. McKnight Road is the small path running west to east at the top of the photograph. (SB.)

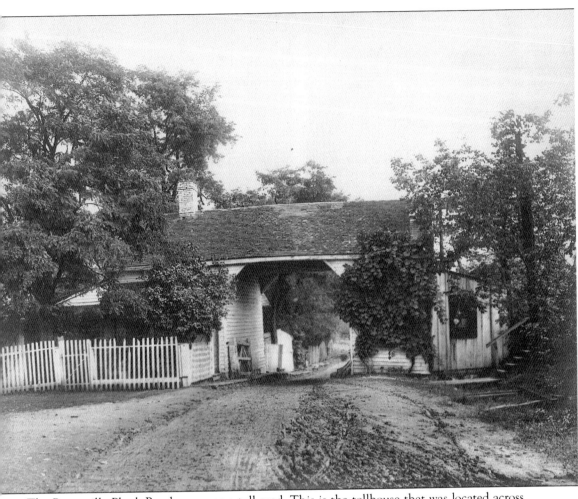

The Perrysville Plank Road was once a toll road. This is the tollhouse that was located across the street from Pines Plaza. The road was constructed to purposely wind and curve so the county could have more opportunities to put up tollgates like this one. (RHS.)

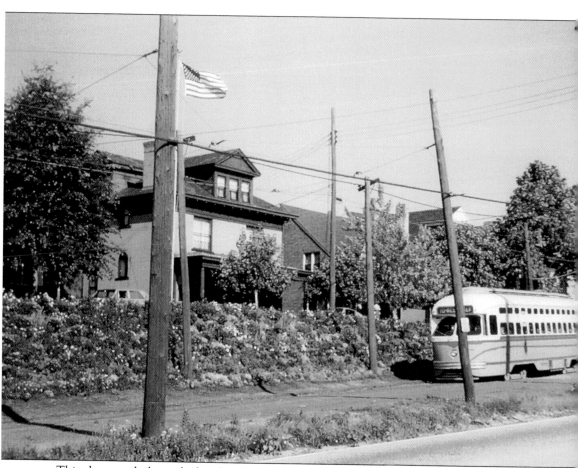

This photograph shows the last day of transit for the Allegheny, Bellevue, and Perrysville Railroad Company on September 5, 1965. Its journey began when it turned onto Tower Terrace and continued down through West View for its last stop at the park. (JM.)

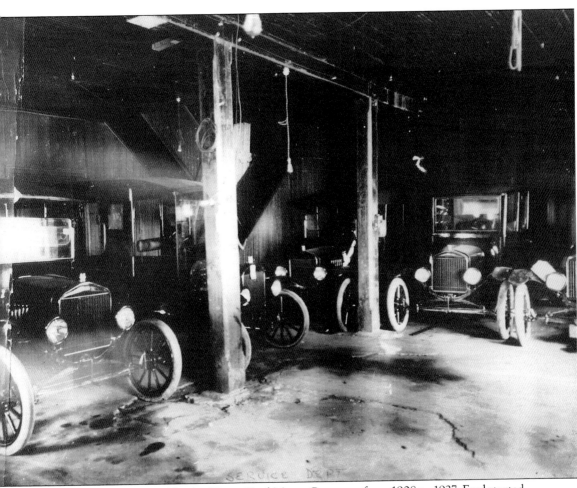

The Model T was produced by the Henry Ford Motor Company from 1908 to 1927. Ford started with a Model A but continued to fail until he reached the 19th model that is known today. It had a 20-horsepower engine and could reach speeds up to 45 miles per hour. This photograph is of a 1910 showroom in an old barn that was located on Perry Highway near Cemetery Lane. (RD.)

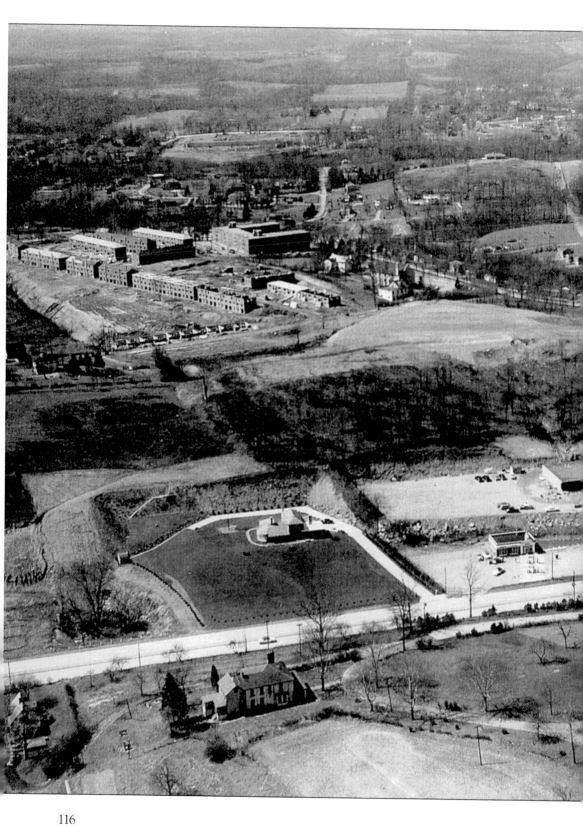

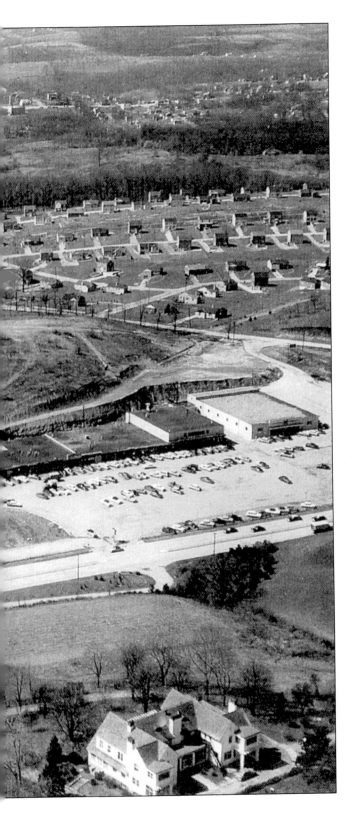

This incredible photograph shows a wide variety of places. To the far upper right is Swan Acres. On the top left is the old Saint Teresa of Avila church cemetery and a barely visible Good Lane. Running west to east at the top is Perry Highway. The large mansion at the bottom right was the Gumbert School for Girls. It was originally a private home that was later converted into a disciplinary detention center for troubled young girls. There are many stories about attempted escapes, although none were successful. In the middle of the photograph is the earliest known picture of the original Northway Mall. In the 1950s it was still in an early strip-mall stage with none of the stores attached. (RHS.)

In this early 1950s photograph, a lone pickup truck drives down a four-lane McKnight Road. The large house in the upper left needed to be moved when Northway Mall expanded. The house was lifted up on planks and shipped into North Park, where it stands today. (HH.)

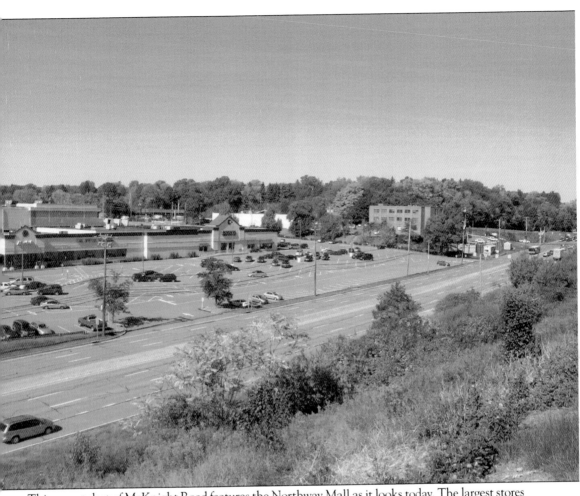

This recent shot of McKnight Road features the Northway Mall as it looks today. The largest stores in operation are Dick's Sporting Goods, Borders, the Fox and Hound Pub and Restaurant, and a Marshall's department store. To the far right is the Ross Township and McCandless Township line. (Author's collection.)

This is the famous Northway Mall birdcage. The phrase "meet you by the birdcage" was just as popular as "meet you under the Kaufmann's clock" during the cage's long stay inside the mall. The birdcage was originally 20 feet high and contained banana trees and toucans imported from South America. (HH.)

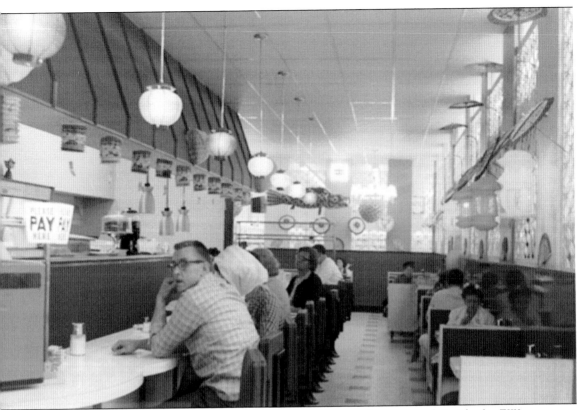

This is a scene that many Ross Township citizens could never forget: a peek inside the F.W. Woolworth's lunch counter. When Northway Mall opened in 1962, one could get an entire turkey dinner at F.W. Woolworth's for just 70¢. Northway Mall officially opened its doors on August 1, 1962, to a crowd of thousands. It was the very first enclosed mall in the country. It opened with 54 stores including the Joseph Horne Company, Hughes and Hatcher, Maxine's House of Fashion, Lane Bryant, Reizenstein's, Woolworth's, G.C. Murphy's, National Record Mart, A&P Grocery Store, Isaly's, and even an eating establishment, the Red Coach Restaurant. (HH.)

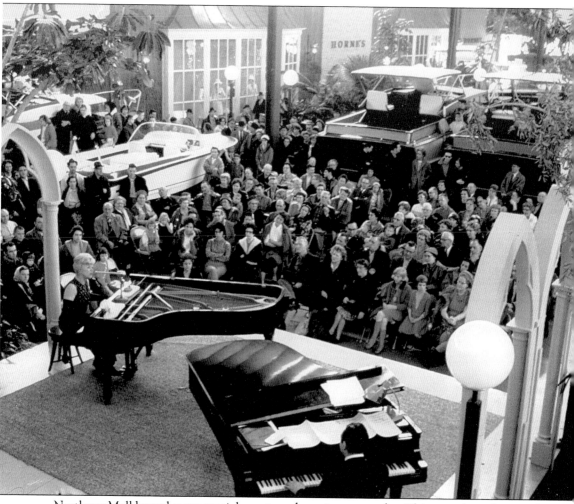

Northway Mall hosted many special events and continues to today. This was a boat show in the 1960s that featured dueling pianos. The mall was known nationally for its exotic plant life and design. It contained almost 7,000 different trees and plants and had to be staffed by a team of full-time gardeners. (HH.)

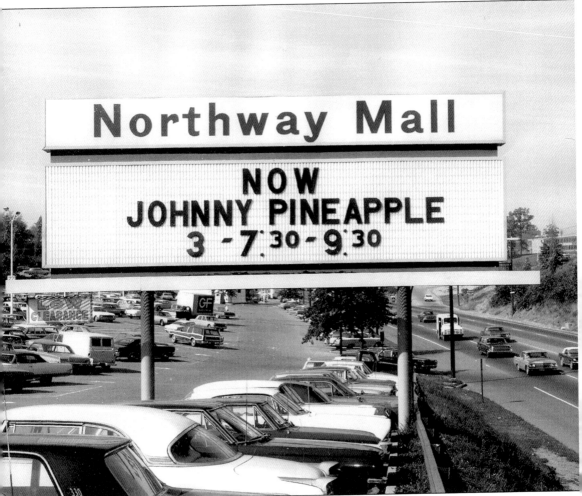

This photograph shows the large sign that advertised all of the different events that took place weekly at the mall. By this time, Northway Mall had added even more stores to its already impressive 54. Being the only mall north of Pittsburgh, it was somewhat of a novelty in its time. People drove all the way from Erie and Ohio just to witness the stunning amenities that the mall had to offer. (HH.)

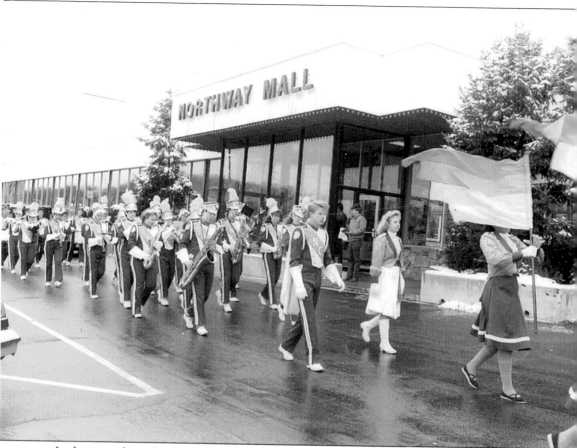

In this annual parade, the North Catholic High School marching band participates in a ceremony along with many other regional schools. The mall was inspired by shopping centers in Paris and other places abroad. It was designed by the eminent architectural team Victor Gruen Associates. (HH.)

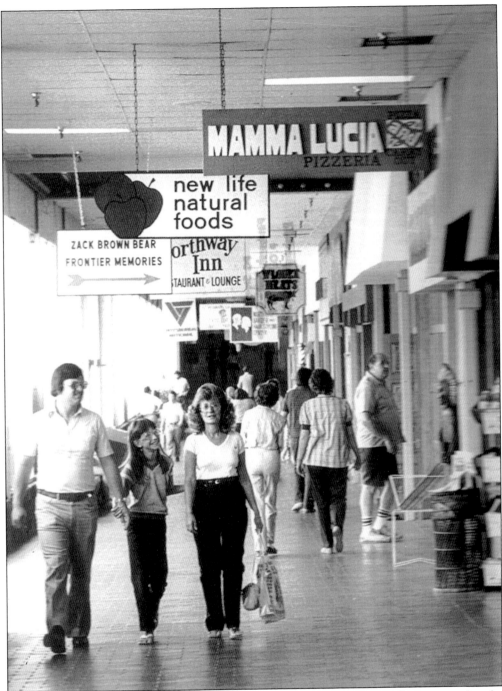

Shown here is a look inside the mall in the 1970s. Mamma Lucia's Pizzeria has remained as the only survivor of the many restaurants in the mall. Many also remember Pappans Family Restaurant, which was located on the top level. Northway Mall had a very unique feature when it opened: its glass-encased elevator. It is hard to believe that it was the third to exist in the entire world. The first was in the Seattle Space Needle, the second in a large hotel in Miami, and the third right here in Ross Township. (HH.)

A lone carriage rolls down a deserted Perrysville Plank Road at the turn of the century. Ross Township residents have said goodbye to the past and look toward creating a new legacy that can

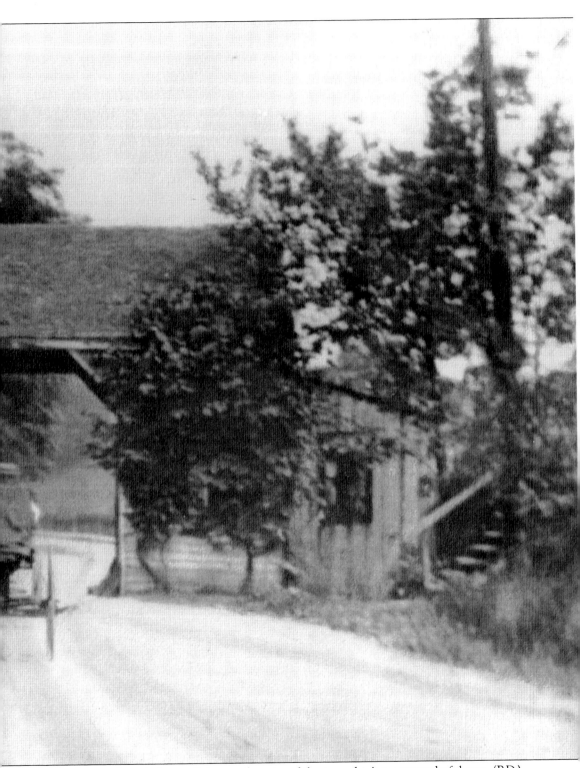

be passed down though the traditions and stories of the township's most wonderful past. (RD.)

DISCOVER THOUSANDS OF LOCAL HISTORY BOOKS FEATURING MILLIONS OF VINTAGE IMAGES

Arcadia Publishing, the leading local history publisher in the United States, is committed to making history accessible and meaningful through publishing books that celebrate and preserve the heritage of America's people and places.

Find more books like this at
www.arcadiapublishing.com

Search for your hometown history, your old stomping grounds, and even your favorite sports team.

Consistent with our mission to preserve history on a local level, this book was printed in South Carolina on American-made paper and manufactured entirely in the United States. Products carrying the accredited Forest Stewardship Council (FSC) label are printed on 100 percent FSC-certified paper.

MADE IN THE